Guz Causey / Editor
93 BW/SAC

Denizens of the Desert
AMARC Photographs by Danny Causey
Copyright © 2008
Photographs by Danny Causey
Edited by Gregory Causey
ISBN 978-1-934446-15-7
Cover Art by VIPER

Published by
Romance Divine 2008
Find us on the
World Wide Web at
www.romancedivine.com

For Our Father,
Dale Causey
He Only Flew Tail-draggers

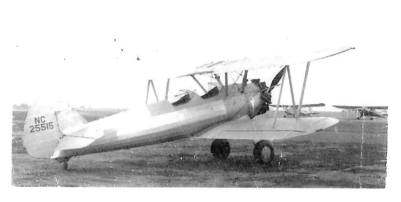

Danny Causey 1956 - 2003

Preface

Late in 2007 I was going through boxes of family photos. My goal was to find pictures I could use to fill a small digital photo frame as a Christmas present for my father. While searching for pictures of my late younger brother, I came across several photo albums filled with aircraft pictures. This was not a complete surprise, as photography and aviation have been recurrent themes between my father, brother and me.

My father followed a life-long passion of photography and aviation, working as a portrait and news photographer and photographing air shows, all while enjoying a long aviation-related career in the government.

I served in the United States Air Force, Strategic Air Command, and attended my share of air shows and took innumerable pictures of aircraft over the years.

But it was the albums of pictures taken by my late brother that caught my attention. Danny served in the Navy, on the carrier USS Midway, and later worked at the United States Air Force Aerospace Maintenance And Regeneration Center (AMARC…don't call it 'The Boneyard'), at Tucson, Arizona. He sadly passed away, too young, from complications due to Diabetes.

I'd collected several boxes of his effects and moved them to our home in Ohio when my wife and I moved my father to be near us. Among these boxes I came upon several albums of photos he'd taken while working at AMARC. As the aircraft came to AMARC, for many it was their last destination, somewhat sad endings to what had been glorious careers in defense of the United States. The great majority of Danny's pictures were of the nose art, those wonderful paintings of seductive ladies, fearsome warriors, cartoon characters and tributes to states or cities.

Many of the aircraft carried close connections to me. As a Doppler Radar Technician (AFSC 32854) I worked on B-52 D/F/G/H aircraft and also KC-135s while assigned to the 93rd Bomb Wing. Later, as an employee at McClellan AFB and while serving in the Reserve 406th Combat Logistics Support Squadron, I spent weekends working on FB-111 and A-10 aircraft. It was easy for me to turn the pages on the photo albums and think back to the times I climbed in the wheel well of a B-52 to change out a Receiver-Transmitter or Frequency Tracker.

I also imagined Danny, parking his vehicle at the end of a row of B-52s, putting on his sunglasses and pulling on his cap to shield his eyes from the relentless Arizona sun. He would walk down endless rows of aircraft, the only sounds the gravel and scrub crunching under his work boots, maybe the scurry of a rabbit, the creaking of massive elevators and rudders in the hot desert wind and the occasional roar of a jet from

nearby Davis Monthan Air Force Base. These are the acts of someone who loves aircraft, who has that special affinity for the hardware, its history, their stories and the men who flew them.

For most of the aircraft, this was their last landing, their last stop in storied histories. They would be cannibalized for spare parts, or cut up and reclaimed for their metals. A special few might find refuge in museums or displays. And one lone man would walk their ranks, photograph them and bid them a last goodbye.

That's how this book came to be. These are the AMARC photographs taken by Danny Causey.

Gregory Causey
Ohio 2008

INTRODUCTION

A Certain Fury, Ace in the Hole, Brute Force, City Of Merced, Grim Reaper, Hoosier Hot Shot, Night Stalker, Angel in de Skies, Moonlight Maid…beautiful women, fearsome warriors, tributes to locations and cartoon characters abound in the following pages.

Images painted on aircraft go back to the earliest days of military aviation, World War I. Famed German ace Werner Voss took advantage of the cooling holes to paint a face on the cowling of his Fokker DRI. French ace Charles Nungesser had a morbid rendition of death, replete with coffin and skull and crossbones, painted on his Nieuport.

While the painting of images began in WWI it certainly reached its zenith in the next major conflict, WWII.

The famous shark-mouthed P-40s of the American Volunteer Group (AVG), the Flying Tigers of WWII, achieved iconic status and the shark mouth motif continues to be popular to this day. It should be noted that German aviators were using the shark mouth as early as WWI.

I suppose the question that begs asking at this point is…why? Why do aviators and ground crews adorn their aircraft with these images? Perhaps it's rooted in psychology: some need to belong with the machine, 'to name it is to claim it.' There is certainly precedence in the reference of ships in the feminine gender, a tendency to anthropomorphize those objects that so closely link to our own destinies.

Or it could be attempts by those far from home, facing perilous circumstances, to provide some semblance of home, to remind them what they're fighting for.

Certainly there are morale aspects, raising one's own warrior instincts or conversely, trying to strike fear in the hearts of the enemy.

I would posit the theory that it is any combination of reasons. Each image evokes its own response, from humorous, to naughty, to ferocious.

Unfortunately, during my time in uniform, such decorations were out of vogue, the victims of political correctness and a different mood about the nature of the military. Certainly I knew about such, having built the requisite model airplanes as a child, reading aviation books and visiting museums, where I saw real nose art.

Like many things in life, art on aircraft came back into vogue. And from what I've seen, the new practitioners of the art have one foot firmly planted in their illustrious heritage while stepping out boldly with the other.

The photographs on the following pages are aircraft from the modern era. The artists, all certainly too young to have been around in that heyday of glorious nose art, have nonetheless captured the spirit, and a glorious tradition lives on.

Many of these artworks were cut from the aircraft and put on display at the Cold War Gallery of the National Museum of the United States Air Force at Wright-Patterson AFB, Ohio.

I've seen these works of art there, and I'm glad that they were preserved. But I prefer my brother's photographs. Perhaps it's a familial bias, but for me, his photographs put the work in context. The image of the nose art on a bomber, perhaps with the sight of others in the background, bits of spraylat peeling off, or a fairing open, perhaps to remove some piece so that a B-52H may soldier on, to me that evokes more response than a piece of metal cut out and put on display.

Please enjoy modern day aircraft nose art photographed by Danny Causey.

B-52 Stratofortress

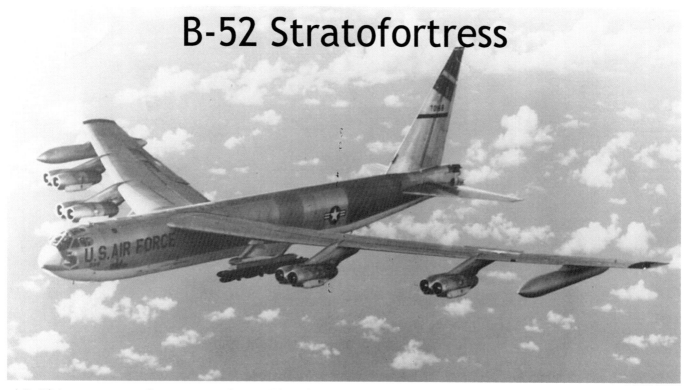

A B-52 in a pre-camoflage paint scheme. There's no nose art, other than the Strategic Air Command (SAC) crest on the nose. This one is carrying a load of bombs on external wing racks.
(U.S. Air Force photo from the McClellan AFB History Office archives).

It's not a cliche' to say that the Boeing B-52 Stratofortress is older than many of those who fly and crew it. The last production model, a B-52H, rolled off the Wichita, Kansas assembly line in 1962. Over eleven years, there were seven different B-52 models built for a total production of 742 aircraft. At one time, there were thirty-eight B-52 combat wings, with over 700 aircraft. Thirteen years after the last B-52H was built, a B-52I model, with four engines and improved electronics was proposed, but this never got past the concept stage. Originally intended to have a service life of 5,000 hours, many of the B-52s pictured in this book flew into AMARC with over 13,000, 14,000, even 16,000 hours on these rugged airframes.

Over its long career the B-52 has carried a wide array of weapons designed to deter nuclear war, drive enemies to the negotiation table, support ground troops, and destroy enemy command and control. These missions required nuclear weapons, high-tech smart weapons, and conventional bombs. A series of modifications have continued to make the B-52 a front-line weapon for decades.

Most of the pictures that follow are B-52 G models, decommissioned from active service after the Gulf War, where many of them served their last and gallant duty.

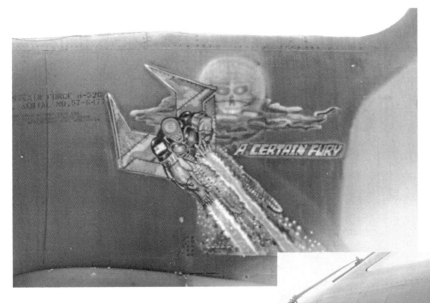

"A Certain Fury"

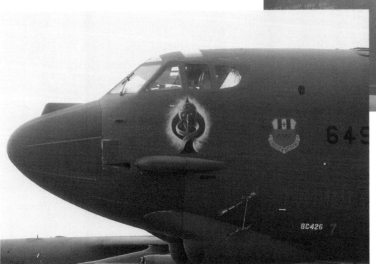

"Ace in the Hole" was assigned to the 416th BW, Griffiss AFB. This aircraft carries ten combat mission markers. **B-52G 6498**

B-52G *"Against the Wind"* is one of the outstanding examples of nose art painted by SSgt Ron Cooke of the 93rd Bomb Wing, Castle AFB.
B-52G 57-6499

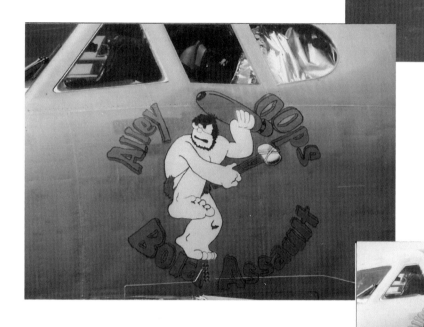

"Alley Oops Bold Assault" flew 46 missions over Iraq during operation Desert Storm. The mission markings can be seen on the aircraft.
B-52G 58-0159

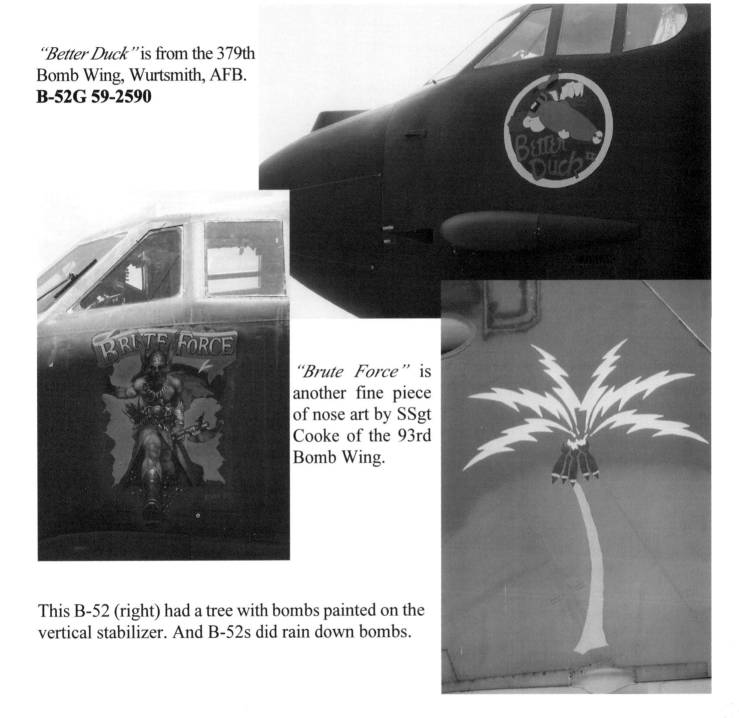

"Better Duck" is from the 379th Bomb Wing, Wurtsmith, AFB. **B-52G 59-2590**

"Brute Force" is another fine piece of nose art by SSgt Cooke of the 93rd Bomb Wing.

This B-52 (right) had a tree with bombs painted on the vertical stabilizer. And B-52s did rain down bombs.

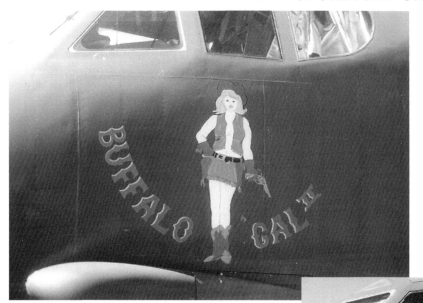

"Buffalo Gal II"

"Buffasaurus" flew its last mission to AMARC from the 2nd Bomb Wing at Barksdale AFB.
B-52G 58-0194

"City of Merced" is another piece of 93rd Bomb Wing artwork created by SSgt Ron Cooke.
B-52G 58-0207

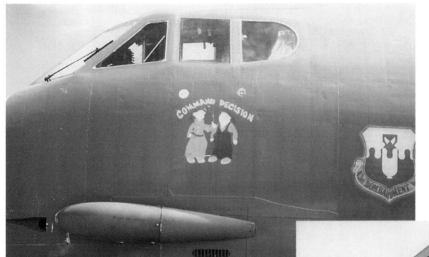

"Command Decision" is from the 43rd Bomb Wing

"Damage Inc." is another B-52G from the 93rd BW with artwork by SSgt Cooke.
B-52G 58-0254

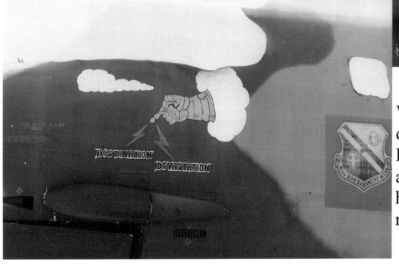

"Destination Devastation" 93rd Bomb Wing. In 1955 the first B-52 s were delivered to the 93rd BW, Castle AFB. In 1957 three B-52s from the 93rd set an around-the-world record flight in 45 hours and 19 minutes, averaging 530 mph over 24,325 miles.

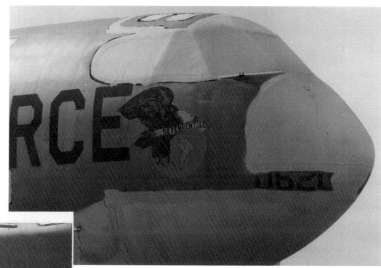

"Deterrent II"

"Disaster Master" came from the 42nd Bomb Wing at Loring, Maine. It had almost 18,000 flight hours when it made its last landing at AMARC. I later worked at The old Loring AFB after its closure, and one could often see moose and bear roaming what was once the base. (editor).
B-52G 58-0232

"Equipoise II" is a B-52G, with nine combat mission markers, from the 2nd Bomb Wing, Barksdale AFB. Note the map of Louisiana on the side of the aircraft.
B-52G # 0245

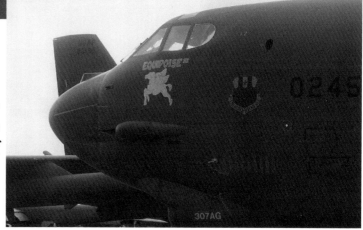

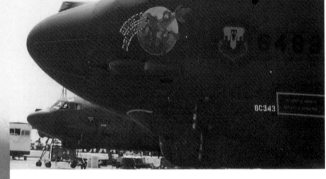

"Express Delivery"

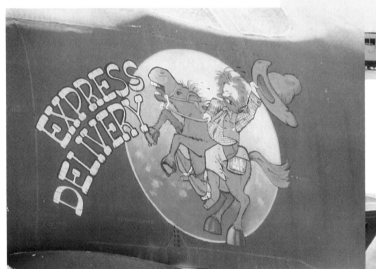

"Grim Reaper" holds center stage on this B-52G from the 2nd Bomb Wing, but first found fame on a B-17 from the 97th Bomb Group. **B-52G 59-2582**

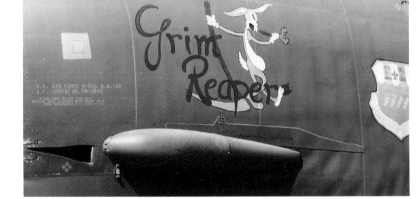

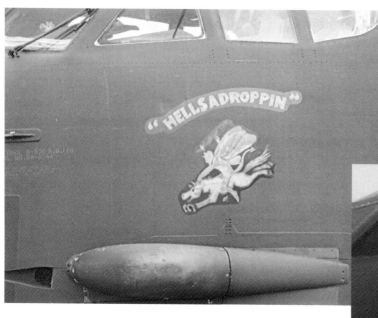

"Hellsadroppin"
B-52G 58-0244

"High Roller"
B-52G 58-0231

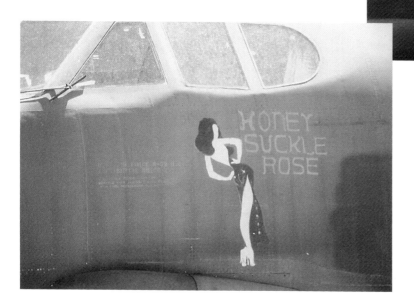

"Honeysuckle Rose"

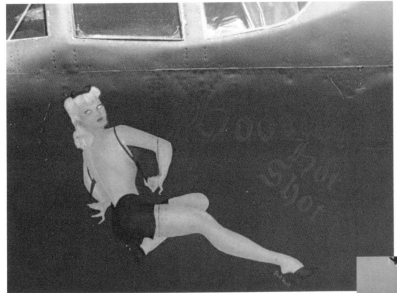

"Hoosier Hot Shot" is a B-52G 340th Bomb Sq. 97th Bomb Group, Eaker AFB. The name originated on a B-17F from the 91st Bomb Group that was shot down over Kassel, Germany.
B-52G 57-6486

"Jolly Roger" artwork is signed by "K.L. North."

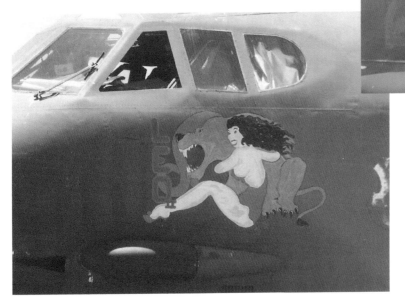

"Leo II" was assigned to the 2nd Bomb Wing, Barksdale AFB.
B-52G 57-6518

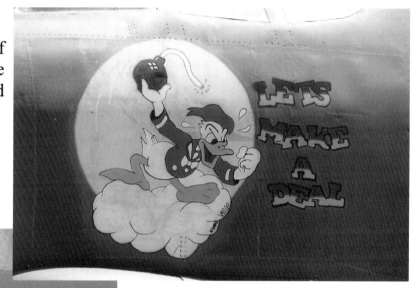

"Let's Make A Deal" a B-52G of the 2nd Bomb Wing, Barksdale AFB, Louisiana. This is signed "Norris Vargo."
B-52G 58-0173

Also from the 2nd Bomb Wing, Barksdale AFB, is *"Lil Peach II."*
B-52G 58-0171

"Little Patches II"

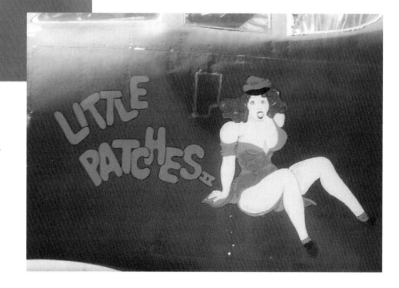

11

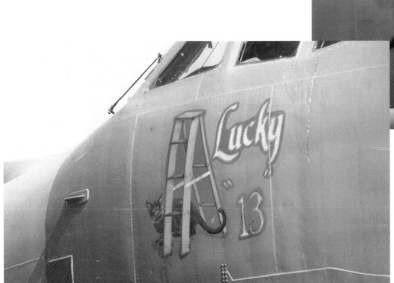

"Lone Wolf" is from the 379th Bomb Wing, Wurtsmith AFB.
B-52G 57-6474

"Lucky 13" is a B-52G from the 97th Bomb Wing. Luck was certainly with this aircraft, which finished its career with more than 16,000 flight hours.
B-52G 58-0236

"Memphis Belle" from the 97th BW is a historic aircraft moniker, seen on many different aircraft over the years. It was a famous B-17 in WWII , *"Memphis Belle II"* was found on an F-105D of the 355th TFW of Vietnam fame, and this B-52 from Barksdale AFB sports *"Memphis Belle III."*
B-52G 59-2594

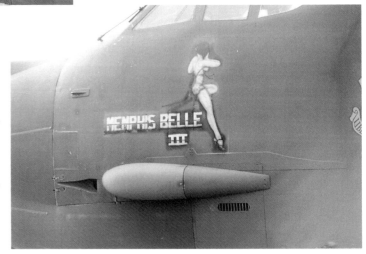

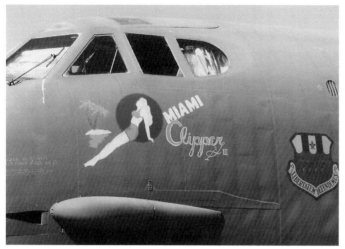

"Miami Clipper II" was part of a mission called, by its crews: Secret Squirrel. At the start of Operation Desert Storm this aircraft flew in the number four slot of a seven B-52 ship formation. From its home at the 2nd Bomb Wing, Barksdale AFB, *"Miami Clipper II"* flew to Baghdad, fired its Air-Launched Cruise Missiles, and returned to Barksdale AFB, a thirty-four mission!
B-52G 57-6475

"Miss Fit" was also the name of a B-24 that was christened at the Ford Willow Run plant. Miss Fit was also the number 5 aircraft in the Secret Squirrel mission.
B-52G 58-0238

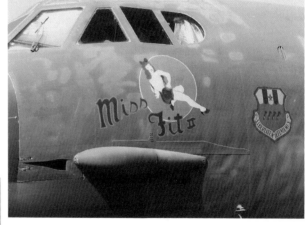

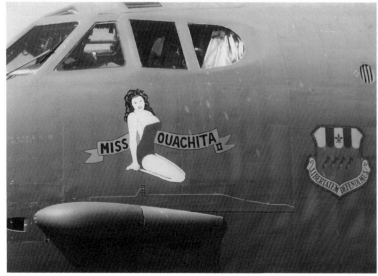

"Miss Ouachita II" from the 2nd Bomb Wing, Barksdale AFB, carries the stenciled 'inscription': "Dedicated to WWII B-17 91 BG ACFT 42-3040."
B-52G 58-0184

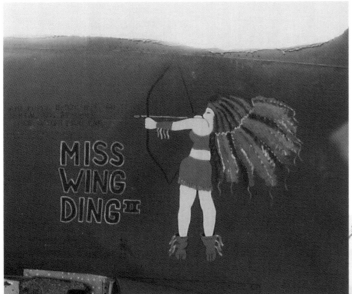

"Miss Wing Ding II" flew to AMARC from the 2nd Bomb Wing at Barksdale AFB.
B-52G 57-6485

"Mohawk Warrior" was a proud B-52 from the 2nd Bomb Wing , Barksdale AFB.
B-52G 57-6515

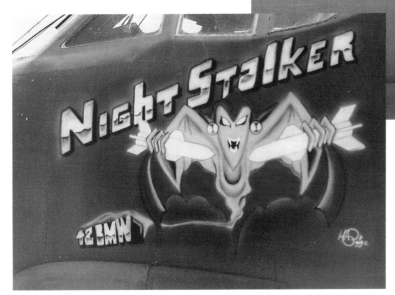

"Night Stalker"

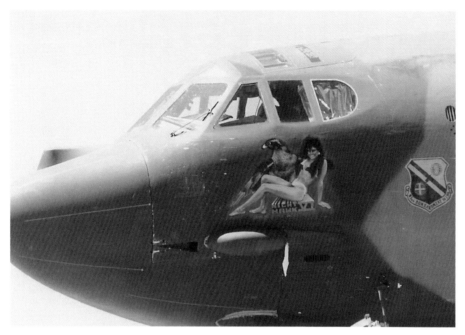

"Night Hawk VI" is another terrific piece of nose art by SSgt Ron Cooke of the 93rd BW. I was already gone from Castle AFB for several years when these examples of nose art began to appear on the unit's aircraft, sorry I missed it (editor). **B-52G 58-0220**

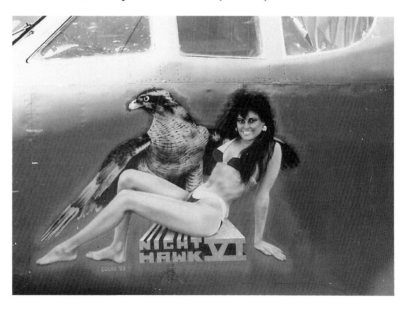

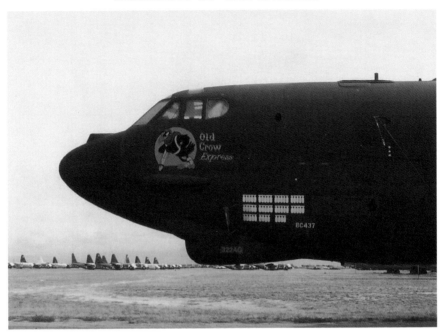

"Old Crow Express" was the last B-52 to fly out of Wurtsmith AFB when the base closed in 1993, as a result of the Base Realignment Closure decisions of 1991. The *"Express"* and her crews flew fifty four missions over Iraq, as can be seen by the mission markers on the nose. This is one of my favorite pictures in the book: the no-nonsense, cigar-chompin' crow with his bomb and the mission markers, all heralding a gallant warplane and her crew.

B-52G 57-6492

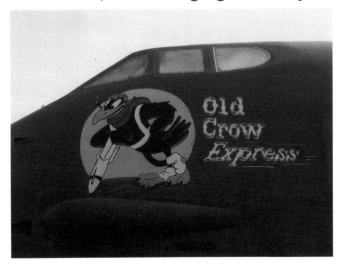

"Outhouse Mouse II" is the latest of a design first painted on a 91st Bomb Group B-17 in England in WWII. The artist of the first *"Outhouse Mouse"* was Anthony L. Starcer, who painted many 91st aircraft. This B-52 displays its faded combat mission markers.

"Petie 3rd" bears a likeness to *Urban Renewal.*
B-52G 58-0177

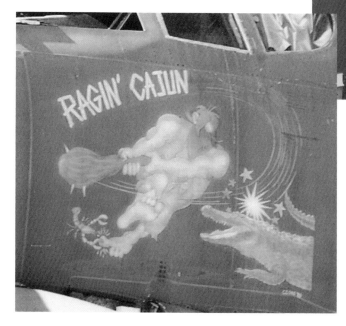

Where else would *"Ragin' Cajun"* be based but the 2nd Bomb Wing, at Barksdale AFB, Louisiana? This is another excellent example of modern day nose art by SSgt Cooke.
B-52G 57-6483

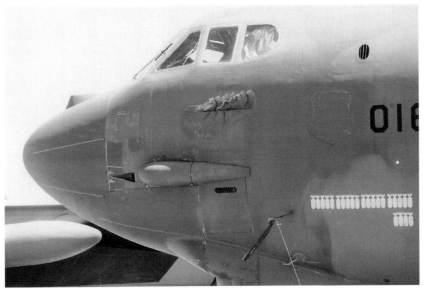

"Rolling Thunder" shows several combat mission markers. Rolling Thunder was one of the nicknames given to B-52s, and came from the massive thunder that rained down when a flight of three ships dropped their 318 bombs. They were also called BUFFs: Big Ugly Fat Fellows. The "Fellows" was often replaced with a more 'colorful' epithet.

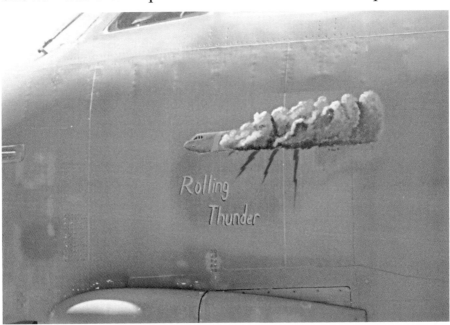

"Ragin' Red" was assigned to the 416th Bomb Wing, Griffiss AFB. It flew combat missions in support of Operation Desert Storm, note the bomb mission markers...and the Camel (?).
B-52G 57-6501

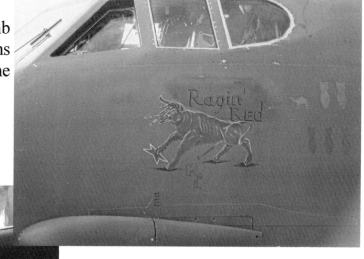

"Sagittarius II" is a veteran from the 2nd Bomb Wing, Barksdale AFB.
B-52G 58-0252

Another veteran from Castle AFB, the 93rd Bomb Wing, was *"Screaming for Vengeance."* The artist was SSgt Ron Cooke.
B-52G 57-6470

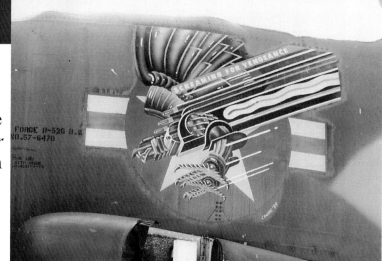

19

"Sheriff's Posse No. 2"

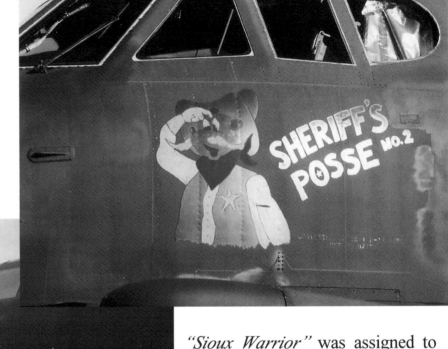

"Sioux Warrior" was assigned to the 2nd Bomb Wing, Barksdale AFB.
B-52G 58-0229

"Snake Eyes" by that modern day nose art master, SSgt Ron Cooke.

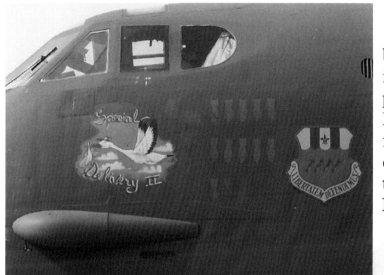

"Special Delivery II" has a heritage of being on B-17, B-25 and B-29 aircraft in WWII. Here it delivers its deadly package from a B-52G from the 416th Bomb Wing, Griffiss AFB. Note the faded mission markers indicating 20 combat missions over Iraq in Operation Desert Storm.
B-52G 58-0170

"Specter" was painted by SSgt Cooke of the 93rd Bomb Wing.
B-52G 58-0199

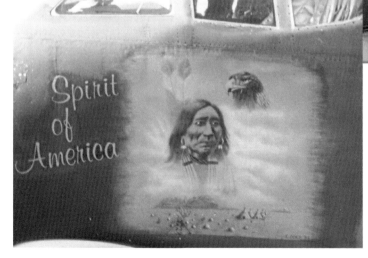

"Spirit of America" from the 93rd Bomb Wing, Castle AFB, was another example of aircraft nose art by SSgt Ron Cooke. His subjects were diverse and always well crafted.
B-52G 58-0223

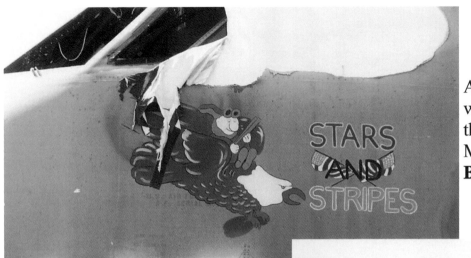

Another California veteran was *"Stars and Stripes"* from the 320th Bomb Wing at Mather AFB.
B-52G 57-6478

"Stratofortress Rex" was assigned to the 93rd Bomb Wing, Castle AFB. With its hulking size and lizard-green paint job, the B-52 looked very dinosaur-like.
B-52G 59-2587

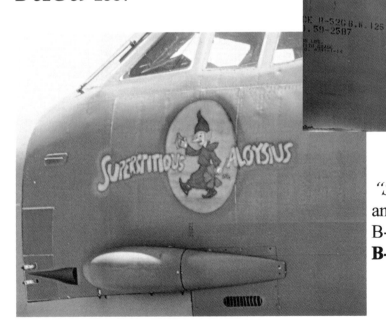

"Superstitious Aloysius" was also used, among others, on an 8th Air Force P-47 and B-24 in WWII.
B-52G 57-6503

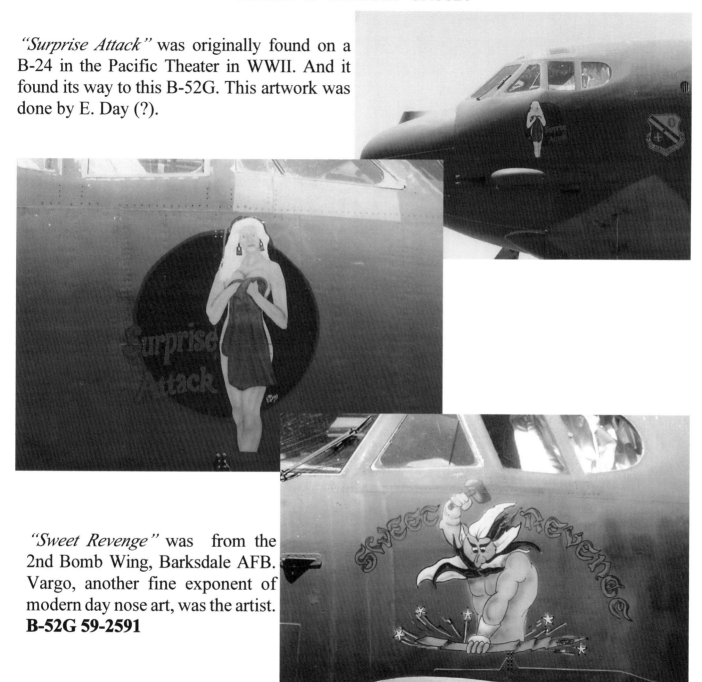

"Surprise Attack" was originally found on a B-24 in the Pacific Theater in WWII. And it found its way to this B-52G. This artwork was done by E. Day (?).

"Sweet Revenge" was from the 2nd Bomb Wing, Barksdale AFB. Vargo, another fine exponent of modern day nose art, was the artist. **B-52G 59-2591**

"Tantalizing Takeoff" has a very retro, WWII feel.
B-52G 57-6471

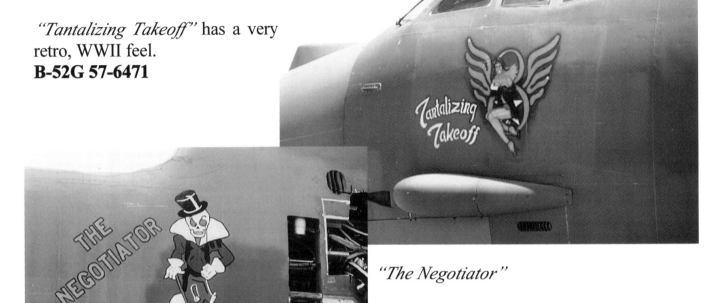

"The Negotiator"

"Ultimate Warrior" was the last B-52 out of the 416th Bomb Wing at Griffiss AFB. The mission markings, though faded, indicate this aircraft flew twelve combat missions over Iraq in support of Operation Desert Storm.
B-52G 57-6516

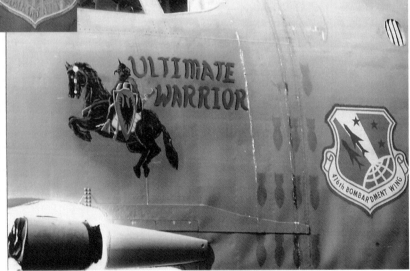

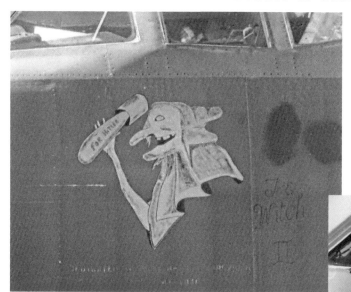

"The Witch II"

"Urban Renewal" was a 379th Bomb Wing veteran. The nose art is signed by "Vargo."
B-52G 58-0249

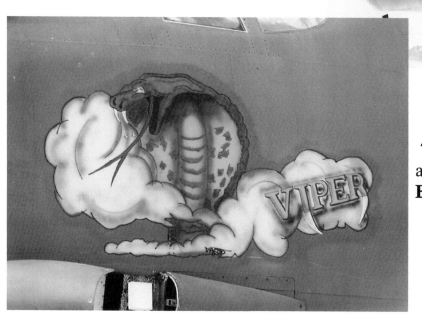

"Viper" is a fine work by artist "Vargo."
B-52G 58-0175

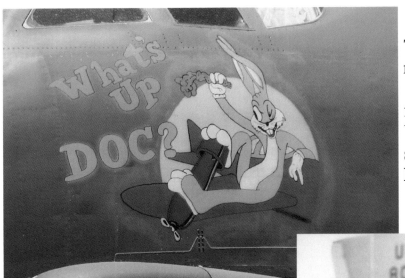

The irrepressible Bugs Bunny makes yet another appearance on *"What's Up Doc?"*, a B-52G from the 379th Bomb wing at Wurtsmith AFB. Again, this is signed by "Vargo."
B-52G 58-0182

This unnamed image shows a ghostly specter calling down thunder and lightning.

"Wild Thing" flew with the 93rd Bomb Wing, Castle AFB. The artwork is signed "Nate 89."
B-52G 57-6486

26

The original *"Yankee Doodle"* featured the same 'Uncle Sam' and was found on a 97th Bomb Group B-17 in WWII.
B-52G 59-2602

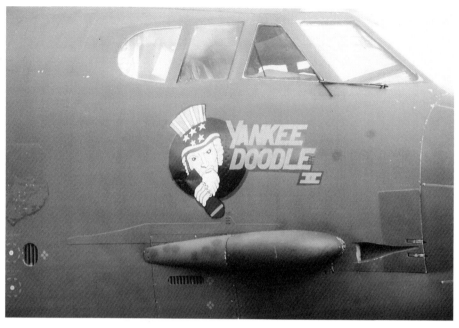

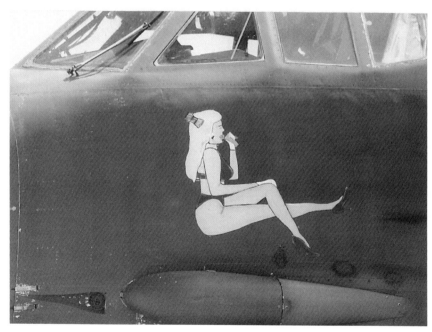

This B-52 sports a shapely, yet unnamed blond woman, who reposes with a drink.

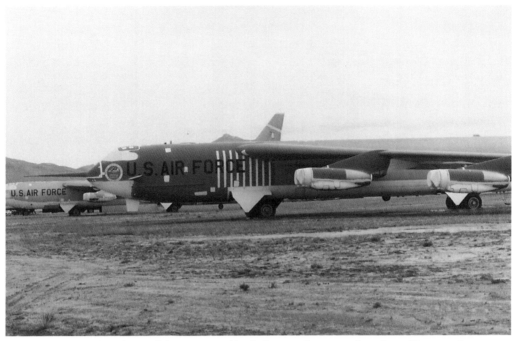

This is the second B-52E built and it was pulled from the production line to become a test and evaluation aircraft, the NB-52E. It was used extensively in a program called Control Configured Vehicles. CCV was conducted as a joint effort of Boeing and the Air Force Flight Dynamics Laboratory (below right). NB-52E had three canard control surfaces (far right) linked to computers, a very effective means of reducing the load effects of turbulence.

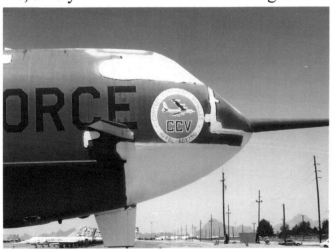

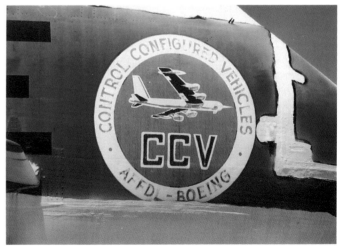

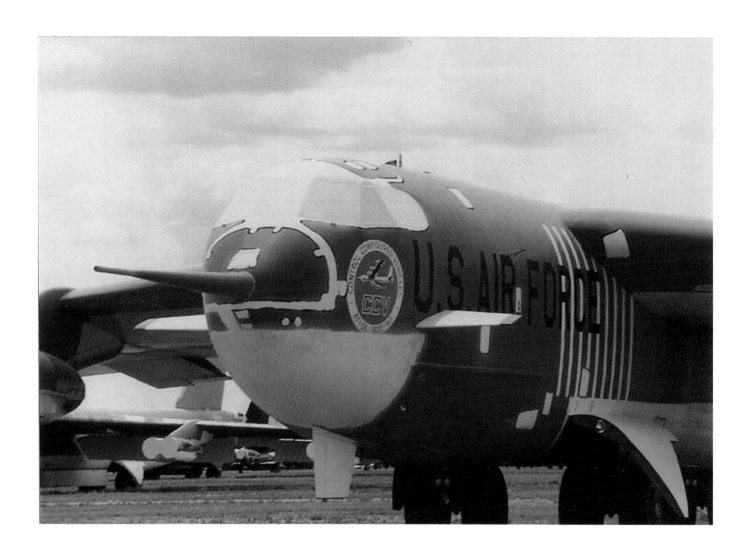

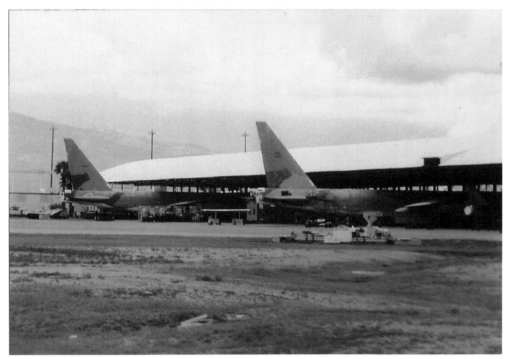

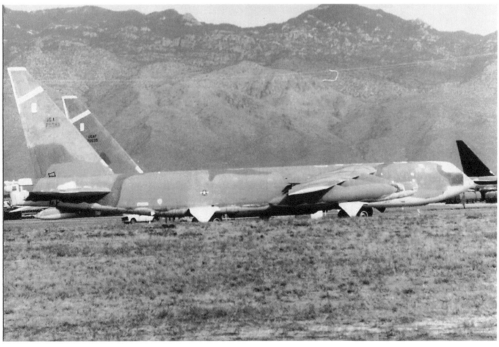

KC-135 Stratotanker

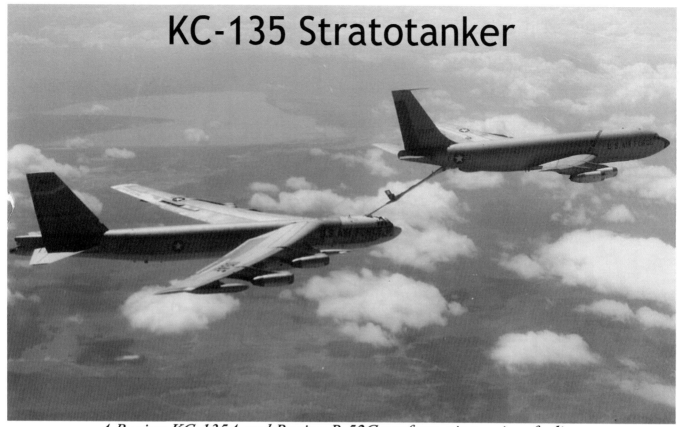

A Boeing KC-135A and Boeing B-52G perform air-to-air refueling.
U.S. Air Force photo from the McClellan AFB History Office archives.

Aerial refueling has truly given the U.S. Air Force 'Global Reach, Global Power.' There is no place on earth that can't be reached by U.S. Air Force combat aircraft. No nation on earth has developed this capability to the same degree. This American technical lineage goes back to 1923 when two DH-4 biplanes used a hose to refuel, allowing one of the aircraft to stay aloft over thirty-seven hours.

Boeing experimented with in-flight refueling as early as 1920 with their 'Boeing Hornet Shuttle' cross-country flights. With the advent of the jet transport, the Boeing 707, and Boeing's development of the 'Flying Boom' the venerable KC-135 came to be, and the first one rolled out from the Boeing plant in 1956. Like its stable mate the B-52, the KC-135 Stratotanker has provided literally decades of service, and many are still flying. The airframe has proven very adaptable, seeing service as a cargo aircraft, airborne command and control center, and in a variety of test and research duties.

At the time of this book's publication, 2008, the U.S. Air Force is still seeking a suitable replacement. How long will the Boeing B-52 and KC-135 continue to fly on? No one knows.

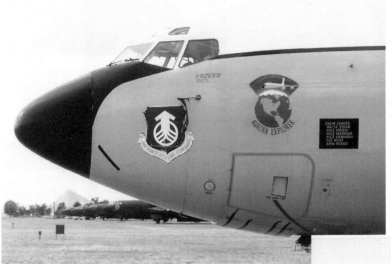

The *"Aurora Explorer"* was an NKC-135A from the 4950th Test Wing at Wright-Patterson AFB.
NKC-135A 55-3131

"Big Bad Boom" was assigned to the 410th Bomb Wing, K.I. Sawyer AFB.
KC-135A 56-03637

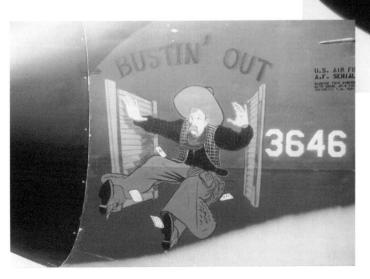

"Bustin' Out"
KC-135A 56-03646

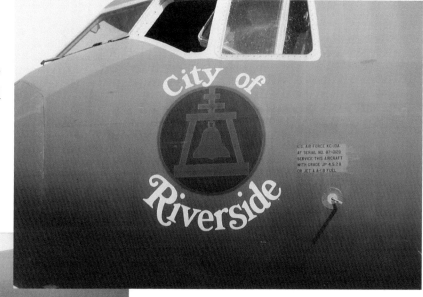

"City of Riverside" is a KC-10 tanker, but it's been included with it's sister KC-135's.
KC-10A 87-0120

"Flying Ace" Snoopy flies his dog house, complete with refueling boom. This KC-135 flew with the 7th Bomb Wing.
KC-135A 3653

"Freedom's Best"
KC-135A 56-3634

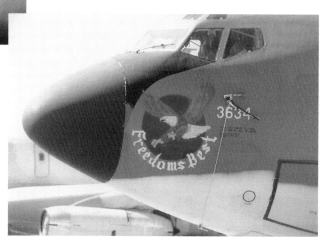

"*Kah wam de meh*" was painted by D.S. Whitney.
KC-135A 3644

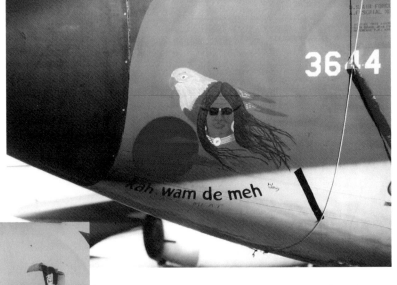

"*Stone Age Mutant Ninja Tanker*" was assigned to the 1701st Air Refueling Wing. An obvious play on the popular 'Mutant Ninja Turtles' this uses refueling booms for the characteristic martial arts weapon the Nunchuka. Photographer Danny Causey was quite adept at the use of the 'Nunchuk'. **KC-135A 56-3633**

"*Running Free*"
KC-135A 62-3539

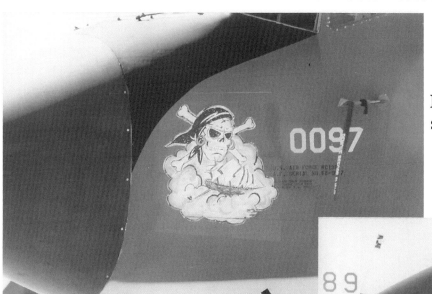

KC-135A 58-0097 sports a pirate skull and crossed bones.

KC-135A *"Swamp Rat"* hails, naturally, from bayou country, the 2nd Bomb Wing, Barksdale AFB.
KC-135A 56-03636

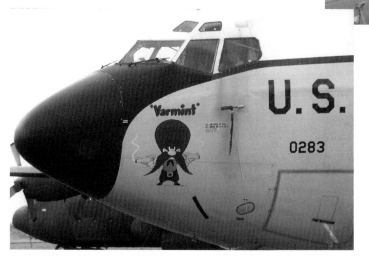

"Varmint" features famed cartoon character Yosemite Sam.
EC-135L 61-0283

35

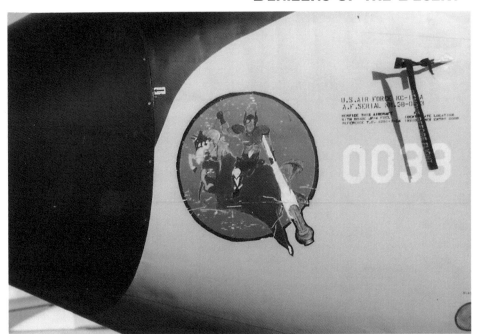

This KC-135 sported nose art with a warrior on a horse. Instead of a lance or a sword, the warrior wields a refueling boom.
KC-135A 58-0038

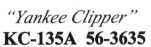

"Yankee Clipper"
KC-135A 56-3635

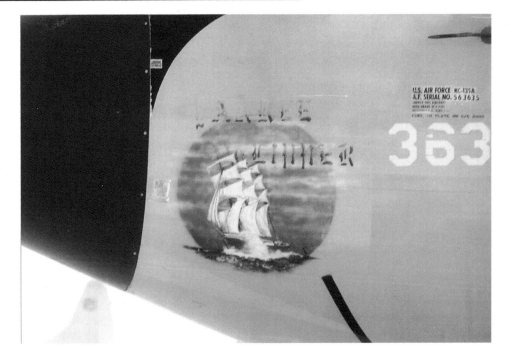

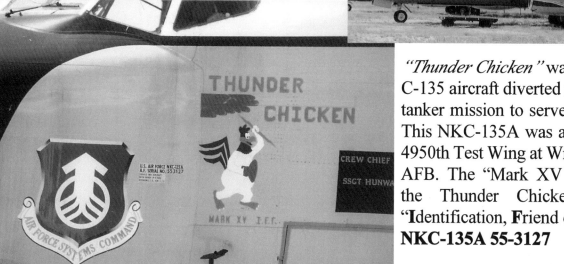

"Thunder Chicken" was one of many C-135 aircraft diverted from a normal tanker mission to serve as a test bed. This NKC-135A was assigned to the 4950th Test Wing at Wright Patterson AFB. The "Mark XV I.F.F." under the Thunder Chicken refers to "**I**dentification, **F**riend or **F**oe."
NKC-135A 55-3127

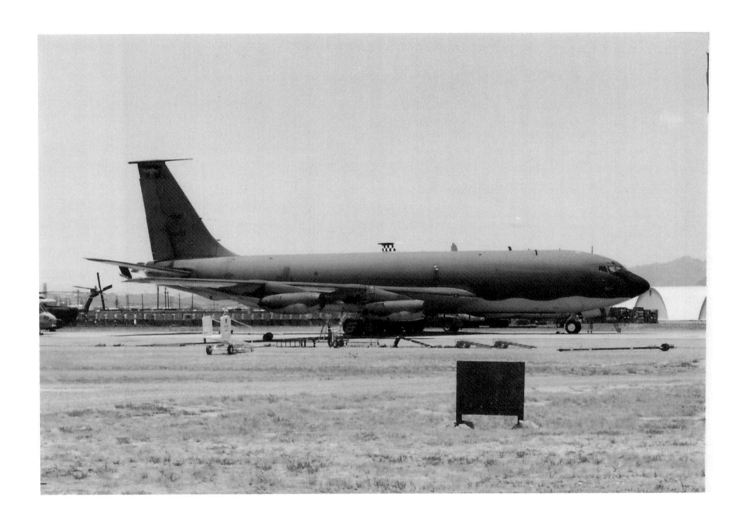

F-111 Aardvark

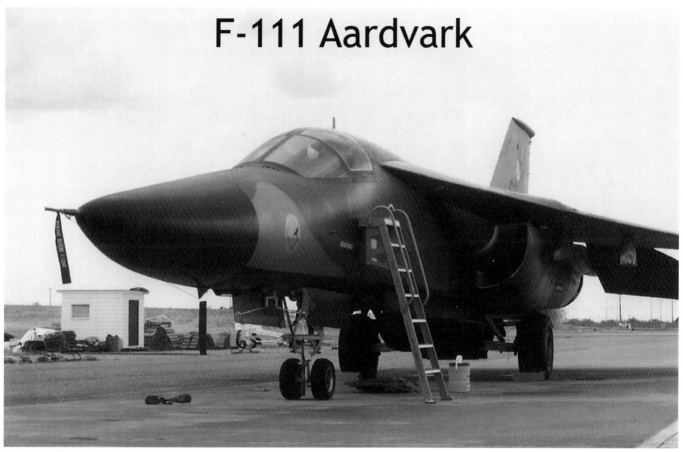

 The General Dynamics F-111 began in 1960 as joint aircraft project TFX, an attempt to design one aircraft serving both Air Force and Navy. The Navy pursued other options, which eventually became the very successful F-14 Tomcat, utilizing the F-111s ground-breaking variable geometry wing. The F-111 employed many innovations such as its variable geometry wing (used on subsequent aircraft), terrain following radar, and after burning turbofan engines.

 The Air Force continued F-111 development and the aircraft entered active service, and combat, in a variety of roles. From 1967 to 1998 the F-111 was the primary Air Force strike and interdiction aircraft, seeing service in Vietnam, a strike against Libya, and in Desert Storm, where sixty-six F-111s destroyed over 1,500 Iraqi vehicles.

 The Strategic Air Command used the FB-111 from 1969 to 1990. An electronic warfare version, the EF-111A, was used by the Air Force until 1998, when the Navy EA-6B Prowler assumed the joint role. When the F-111 was retired by the Air Force it was officially named by the nickname it had forever carried...Aardvark.

The 380th Bomb Wing, Plattsburg AFB was home to many of the following FB-111's.

The 428th TFTS Buccaneers were an F-111G wing at Cannon AFB. The "Gs" were modified SAC FB-111As, and were meant to augment and perhaps replace the role of the B-52. It's 2008 and all F-111s have been retired and B-52s are still flying.

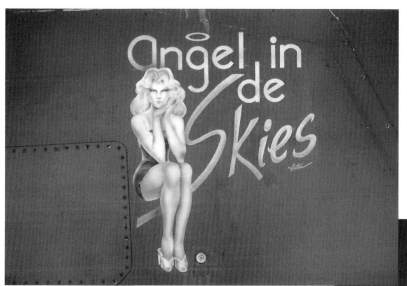

This is one of my favorite pictures from the book. *"Angel in de Skies"* is an FB-111A from the 380th Bomb Wing SAC Plattsburg AFB. As are many in this book, this one takes its name from a WWII 380th Bomb Group WWII B24 Liberator. Artist "Hatton" achieved perfection on this one. **FB-111A 68-0256**

"The Baghdad Express" has twenty-one mission markers on its nose. **F-111E 68-0039**

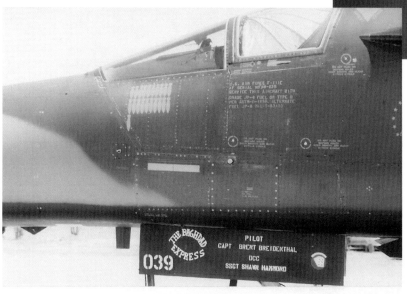

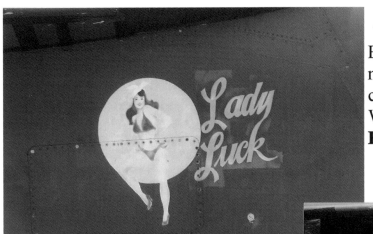

"Lady Luck" is an F-111 from the 380th Bomb Wing. *'Lady Luck'* was also the name of a B-52F, the first to rack up 100 combat missions over Vietnam, and a WWII B-17 from the 303rd Bomb Group. **F-111A 68-0262**

"Liquidator" was another warrior from the 380th Bomb Wing, Plattsburg AFB. The girl in the martini glass was also found on a B-24J named *Liquidator* in the South Pacific in WWII. **FB-111A 67-0161**

The Wing Commander of the 380th Bomb Wing flew FB-111A *"Little Joe"* to AMARC. This aircraft carries the older SAC logo of the mailed fist and lightning bolts. Another *Little Joe*, was a B-24 Liberator, an F-7 reconnaissance version in WWII. **FB-111A 68-0249**

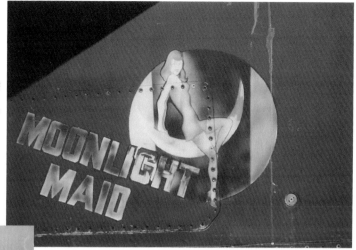

"Moonlight Maid" is an FB-111A that came to AMARC from the 528th Bomb Squadron, 380th Bomb Wing at Plattsburg AFB.
FB-111A 67-0163

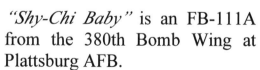

"Peace Offering" is another veteran from the 380th Bomb Wing.

"Shy-Chi Baby" is an FB-111A from the 380th Bomb Wing at Plattsburg AFB.
FB-111A 68-0251

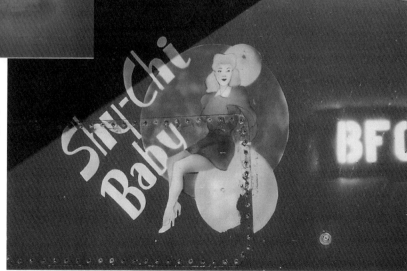

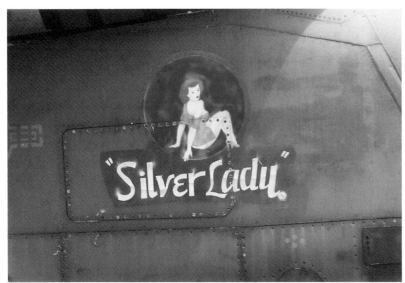

"Silver Lady" is another 380th Bomb Wing veteran. **FB-111A 68-0250**

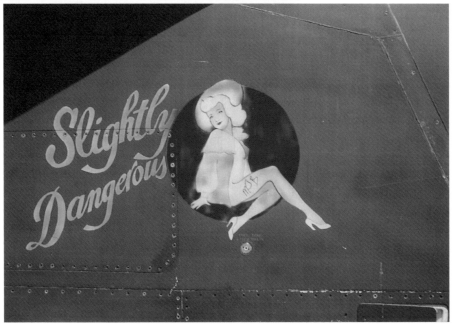

Another aircraft from the 380th Bomb Wing at Plattsburg AFB was FB-111A *"Slightly Dangerous."* With its speed and advanced avionics the FB-111A was more than 'slightly dangerous'. **FB-111A 67-7192**

A-10 Thunderbolt II
"Warthog"

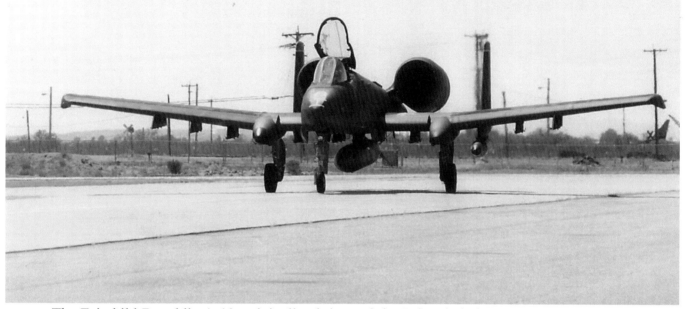

The Fairchild-Republic A-10, originally christened the "Thunderbolt II" after its WWII predecessor the P-47 Thunderbolt, will forever be known to all as - *The Warthog*. Built around its formidable main weapon, the tank-killing GAU-8A 30mm gun, the A-10 is a lethal machine. The aircraft was built to perform a dangerous mission, close air support, in high-threat enemy environments. It looks the way it does for a reason; its design reflected its mission: dual engines away from each other and the fuselage, redundant systems, and an armored cockpit. For much of its service life the expected foe was to be the Warsaw Pact forces flooding across Europe. When this threat was mitigated by the dissolution of the Warsaw Pact, the fate of the A-10 was threatened; some called for its retirement. And then came the Gulf War. The A-10 had the chance to prove itself in combat, in the role it was designed for and what its pilots trained for. Many of the A-10s in the following pages carry "kills" on their nose: tanks, trucks, armored personnel carriers, radar sites, surface to air missile batteries and anti-aircraft batteries all fell to the A-10s deadly gun and other ordnance.

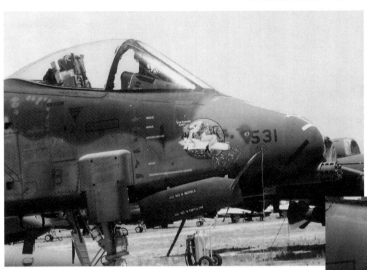

"Bayou Babe" was assigned to the 926th Fighter Wing, 'The Cajuns', at the Naval Air Station, New Orleans. 'Stephanie Ann' is the name of the Bayou Babe. Note the incredible amount of truck 'kills'.

A-10 76-0531

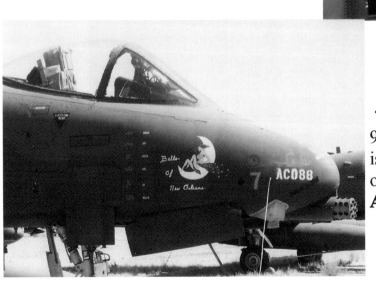

"Belle of New Orleans" is also from the 926th Fighter Wing. The 'crescent' moon is another nod to the New Orleans home of these aircraft.

A-10 77-0269

"Crescent City - Desert Darlyn" pays homage to New Orleans, the 'Crescent City'. Naturally, this aircraft is also part of 'The Cajuns' of the 926th Fighter Wing.
A-10 77-0268

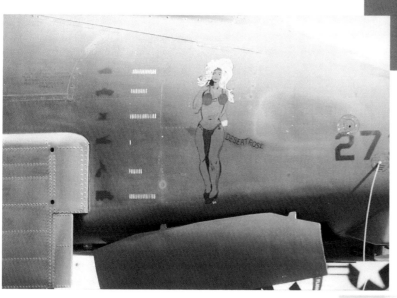

"Desert Rose" is an A-10 from the 926th Fighter Group in New Orleans. Note the kills credited to this aircraft: tanks, trucks, SAM launchers, anti-aircraft and radar sites. The A-10 was a fearsome foe, dealing a wide range of lethal ordnance.

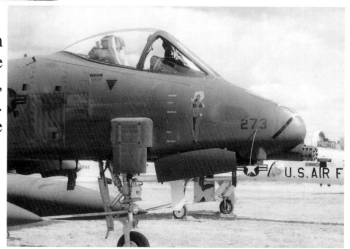

"Desert Storm Heroes: Robert, Francine, David" is a Desert Storm warrior from the 926th Fighter Wing.
A-10 76-0544

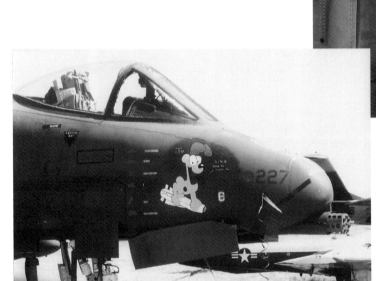

"Odie" of Garfield fame, rides atop an AGM-45 Maverick Missile and says "Ya, Ya By Grace We Licked 'em." This A-10 was assigned to the 926th Fighter Wing.
A-10 77-0227

"Randi Lauren, Brenda Beth" flew with the 926th Fighter Wing, New Orleans.
A-10 77-0240

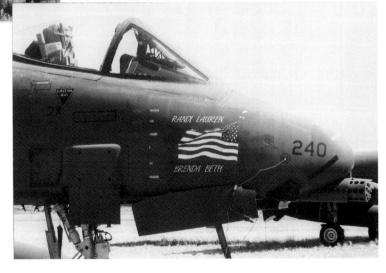

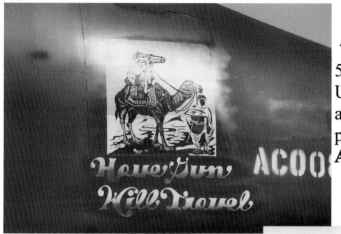

"Have Gun Will Travel" was an A-10 from the 511th Tactical Fighter Squadron, Alconbury, UK. In 1990 it deployed to Saudi Arabia. The artist for this particular work was J. Trago, who painted many of the unit's aircraft nose art.
A-10 79-0224

*"Holy *-+'"* was very likely the reaction of the enemy when the A-10s appeared on the scene. This one flew with the 926th Fighter Wing.
A-10 77-0271

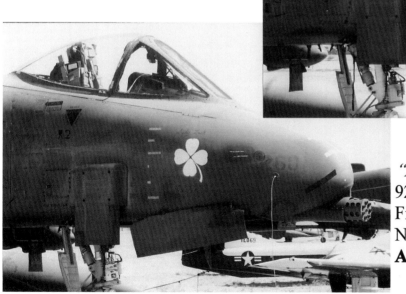

"Lady Luck" was also assigned to the 926th Fighter Wing, 706th Tactical Fighter Squadron, Naval Air Station, New Orleans.
A-10 77-0260

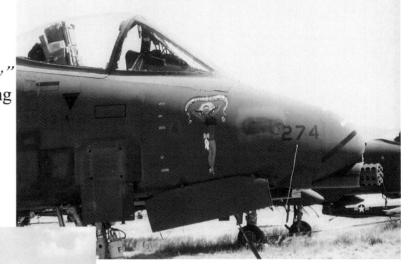

Where else would *"New Orleans Lady"* be from, if not the 926th Fighter Wing at New Orleans?
A-10 77-0274

"Operation Desert Storm" is a 926th Fighter Wing veteran. The nose art is a replication of the patch worn by pilots and ground support personnel.
A-10 77-0272

"Yankee Express" deployed to the desert conflict from the 10th Tactical Fighter Wing at RAF Alconbury, the United Kingdom.
A-10 79-0220

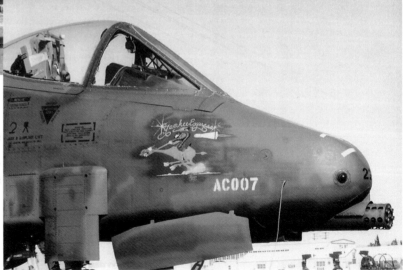

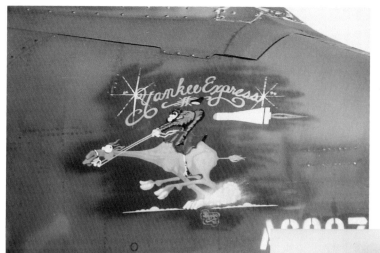

A close up of *"Yankee Express"*

A-10 77-0275 was a Cajun from the 926th Fighter Wing.

There's no name on this A-10, but it bears the likeness of a Wild Boar. The A-10's fearsome gun is evident in the photo.

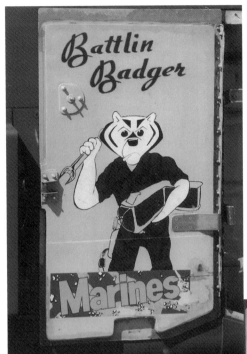

The Dragon below is from an A-10 with the 355th Tactical Fighter Wing, Davis Monthan AFB.
A-10 75-0281

A U.S. Marines fan took the opportunity to emblazon A-10 *"Battlin Badger"* with a Marine Corps sticker. Perhaps it was a tribute in thanks for the awesome amount of air support the A-10 could deliver to Army and Marine troops on the ground. This artwork is on the inside of the access door for the crew boarding ladder.

"Devil Hunter" shows an A-10 pilot's view of the world through a Head Up Display (HUD). While a fellow A-10 goes inverted, *"Devil Hunter"* brings a MIG-29 into range. *Devil Hunter* flew from the 45th Fighter Squadron, known as the 'Hoosier Hogs', Grissom AFB, Indiana.
A-10 77-0249

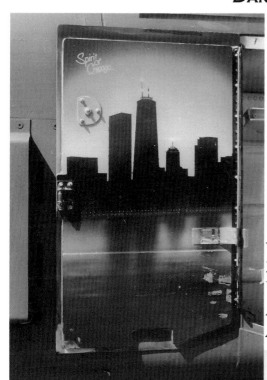

"Spirit of Chicago"

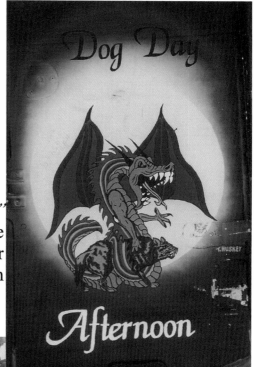

"Dog Day Afternoon" was a veteran from the 355th Tactical Fighter Wing, Davis Monthan AFB.
A-10 75-0278

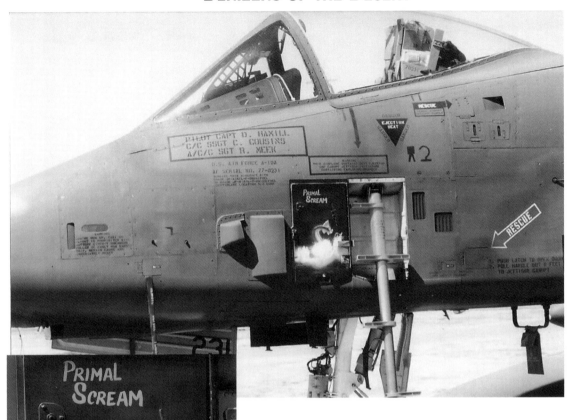

"Primal Scream" flew with the 45th Fighter Squadron, Grissom AFB, Indiana, the 'Hoosier Hogs'. This clearly shows how aircraft art was applied, if needed, surreptitiously. Many A-10s sported outstanding works of art on the inside of the access door that housed the crew boarding ladder. In all outward appearances this A-10 would look to be the typical and standard attack aircraft, known by its tail number 77-0231. But to its pilot and ground crew...it was the *"Primal Scream."*

A-10 77-0231

AMARC's Other Aircraft

Storing aircraft in the Arizona desert began in 1946 when the 4105th Army Air Force Unit was established at Davis-Monthan Air Force base. Over the years the name of the unit changed, but I have chosen the name given in 1985, Aerospace Maintenance And Regeneration Center (AMARC), for the purposes of this book, as that is where my brother worked when he took the photographs. In 2007 it became the 309th Aerospace Maintenance and Regeneration Group (AMARG), but it has also been the 3040th Aircraft Storage Depot (1948) and the Military Aircraft Storage and Disposition Center (MASDC) in 1965. It's also been known by a less popular sobriquet (especially by those who work there): 'The Boneyard'. It is definitely more than an aircraft graveyard.

The Arizona site was chosen for specific reasons: the desert provides low humidity, and the infrequent rainfall and alkaline soil make preservation and corrosion control easier. The hard-packed desert soil provides ready-made ramp space and the ability to move aircraft without paving almost 2,000-plus acres of parking space.

AMARC possesses a capability unique to the US military and critical to national defense. It provides these services to all branches of the US military: Air Force, Navy, Marines, Coast Guard and Army, and even other national agencies. Aircraft can be stored short-term, long-term, salvaged for usable parts or scrap metals, or sold off as whole aircraft or parts. Many aircraft are converted to remote controlled drones for research or live fire combat practice.

AMARC has even played a role in international politics, working with Soviet delegations to monitor provisions of the START (**St**rategic **A**rms **R**eduction **T**reaty) I treaty provisions. AMARC was tasked to destroy 365 B-52s. The pieces were left on the ground for a specified length of time so they could be verified by Russian spy satellites or by on-the-ground, Russian inspectors.

AMARC categorizes its aircraft work by type:

Type 1000 is for aircraft that will eventually fly again.

Type 2000 aircraft will be used as parts donors to keep other aircraft flying ("cannibalizing" is a popular, if gruesome, term for this).

Type 3000 aircraft are temporary storage and may be flown out again in 90 to 180 days.

Type 4000 aircraft have been identified as inventory excess and will be turned over to the Defense Reutilization and Marketing Office (DRMO) for disposal.

Aircraft are painstakingly processed for storage. Explosive items (for seat and canopy ejection) are removed, high-value or security items are removed and inventoried, the lines are flushed of fuels and fluids and filled with a preservative. Finally, the openings are taped, and the aircraft are sealed with spraylat and Kool-Kote, the white covering so prevalent in many of the photographs.

Many aircraft have been processed as QF drone aircraft, among them: 152 F-102 Delta Daggers, 312 F-100 Super Sabers, and 156 F-106 Delta Darts. Over 300 of the venerable F-4 Phantoms will also see use as Drone aircraft.

With the last B-52 coming off the production line in 1962, and with several still flying in 2008, it's not hard to imagine that many of the B-52s consigned to the desert, and eventually scrapped in accordance with the START treaty, gave up some of their precious parts for their active brethren. Similar Type 2000 aircraft give up their valuable parts as an economical way, versus re-tooling and production of new parts, to keep first-line aircraft flying.

Danny worked in supply and had the opportunity to get around the base. He often greeted the pilots of the incoming aircraft, collecting many unique organizational patches in the process. As the many photographs indicate, his camera always seemed to be at the ready. While the B-52, KC-135, F-111 and A-10 make up the bulk of this book, AMARC has played host to many aircraft over the decades. The following pages present some of these many Denizens of the Desert.

F-4 Phantom

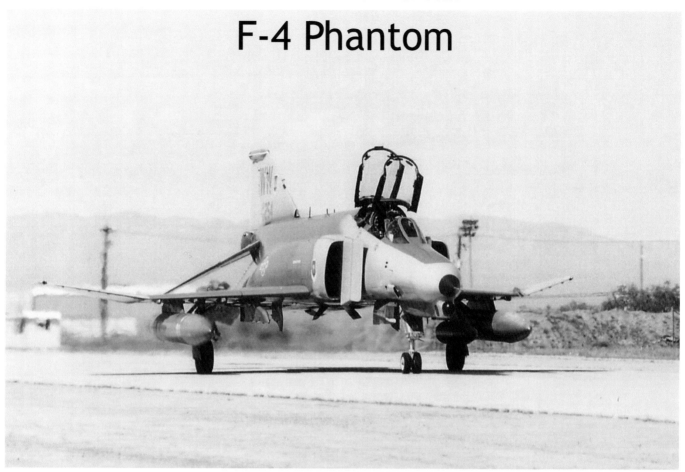

While the F-111/TFX project was a failure at developing a combat aircraft capable of serving both Air Force and Navy needs, the McDonnell Douglas F-4 Phantom II was a resounding success. While it was an original design for the U.S. Navy, the Air Force quickly realized the potential and capabilities of this great aircraft. The F-4 enjoyed a long success, serving in a wide array of models for Air Forces throughout the world. The Phantom was a very successful export product and ended up flying in the Air Forces of: Australia, Egypt, Germany, Greece, Iran, Israel, Japan, South Korea, Spain, Turkey and the United Kingdom.

As a combat aircraft it saw action as a fighter, fighter-bomber, Surface-to-Air-Missile (SAM) suppression, and reconnaissance aircraft. Over 5,000 Phantoms were produced from 1958 to 1981 and it remained an active U.S. Military aircraft from 1960 to 1996. AMARC processed over a thousand of these, rows and rows of Phantoms. Like the F-100s and F-106s before it, the Phantoms ended up as QF-4 target drones used for weapons testing and research.

"ACK!" says Bill the Cat.

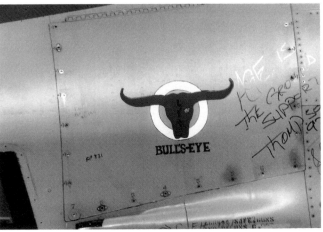

"Bulls-Eye"

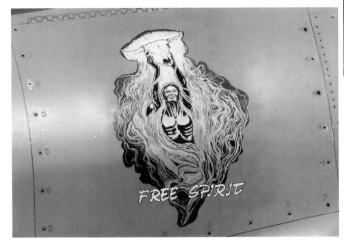

"Free Spirit" flew with the 155th Tactical Reconnaissance Group, Lincoln Nebraska ANG. **RF-4C 64-01062**

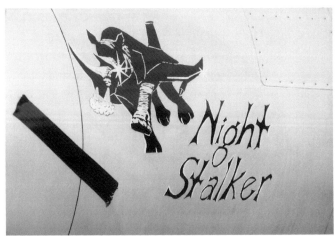

"Night Stalker"

This RF-4C Phantom shows some nice paint jobs with the classic shark's mouth. This aircraft has a *"Recce Rebels"* logo and *"Way To Go Alabama."*

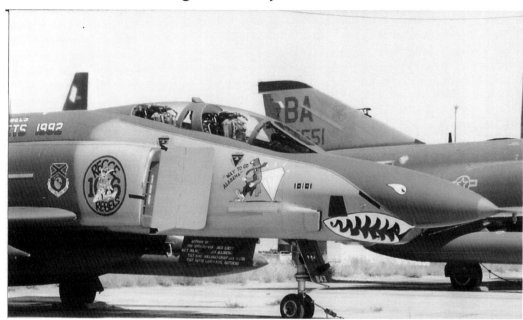

A 75th anniversary *"Jennies to Jets"* and Birmingham 106th Reconnaissance Sq. Emblem are clearly evident. Note the 3 camels on the left engine inlet.
RF-4C 65-0843

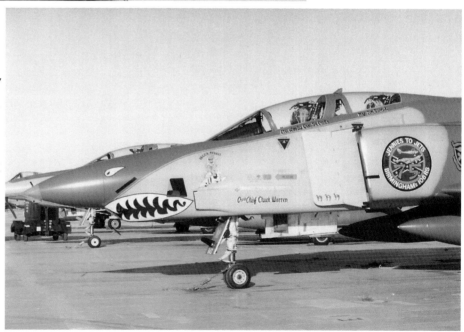

"Thunder Duck"

"Miss Photo Genic" is an apt name for an RF-4 loaded with cameras for recon missions. The sultry lady has a very 40's feel. This RF-4 Phantom saw duty in diverse locations such as the Lincoln Nebraska Air National Guard and at Ramstein Air Base Germany.
RF-4C 64-01066

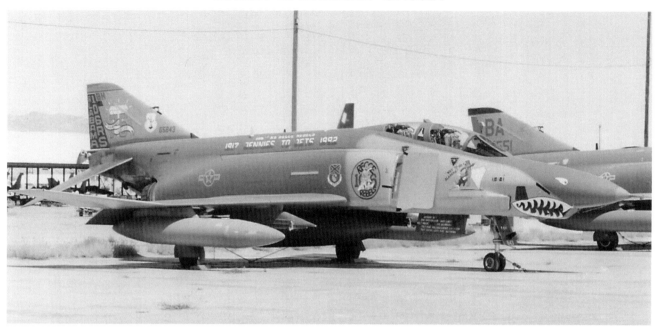

Another view of RF-4C # 65-0843 while the tails of many F-4s (below) line the desert. Many of these will end up as drones, as have F-100s and F-106s before them.

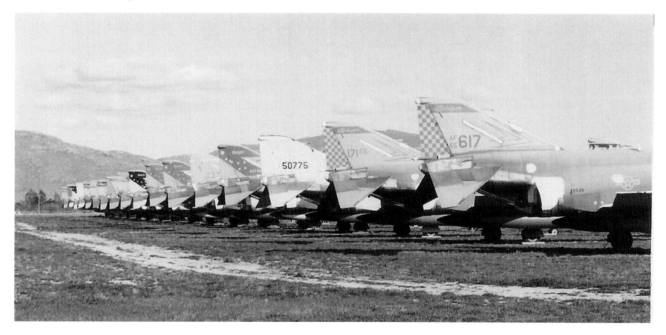

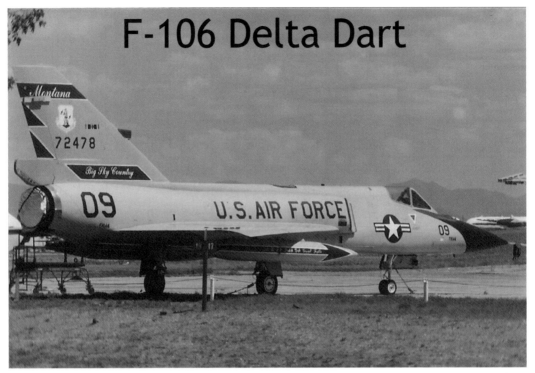

F-106 Delta Dart

The Convair F-106 Delta Dart was the last operational example of the "Century Fighters": F-100 Super Saber, F-101 Voodoo, F-102 Delta Dagger, F-104 Starfighter, F-105 Thunderchief. The F-106 Delta Dart (usually called the "Six" by its pilots) was the primary US Air Force interceptor from the 1960s through 1981. In the 80s the "Six" was replaced by the F-15 and most F-106s ended up going to Air National Guard units. It was the last dedicated interceptor, with subsequent aircraft taking on multiple roles. It served on duty for 28 years and in 1959 Major Joseph W. Rogers flew one (photographs on the following pages) to a world speed record of 1,525.96 mph (2455.79 km/h) 40,500 feet (12,300 m). During its service history it served in the continental USA, Alaska, and Iceland, with deployments to Germany and South Korea.

As a pure interceptor aircraft, many consider the F-106 to be the best of its type. It held its own in mock dogfights with the F-4 Phantom.

The QF-106 Project: Beginning in 1986 many F-106s were converted into drones, designated QF-106A. These drones were used for live fire target practice, the last being destroyed in 1998. The drones could be flown by pilots to ferry the aircraft to the test range, but were flown as unmanned drones for live missile shots. NASA retained a few F-106s for test purposes and used these through 1998. The last QF-106 was shot down at Holloman AFB in 1997. The drone project continues, but the stalwart F-106 has been replaced by QF-4 Phantom drones.

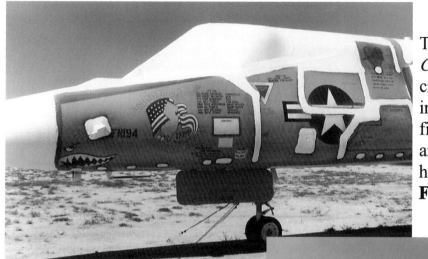

This F-106, *The Spirit of Atlantic City,* is one of the most striking aircraft in the book, a historic aircraft in many ways: last of the century fighters, last of its operational type, and a former world record speed holder.
F-106A 59-0043

B-52Ds lurk in the background as this last operational F-106 takes center stage.

This aircraft contains the signature of many pilots, and squadron members, a tradition going back to WWII when historic aircraft would roll out from the factory with the signatures of all the workers and employees.

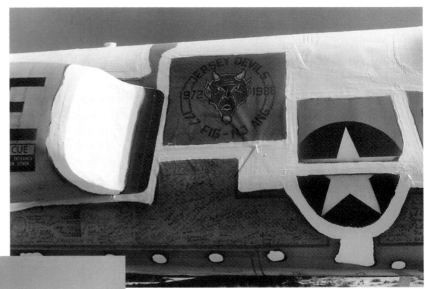

Note the many signatures of those bidding farewell to the last F-106 interceptor.

"The Ultimate Interceptor"

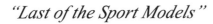

"Last of the Sport Models"

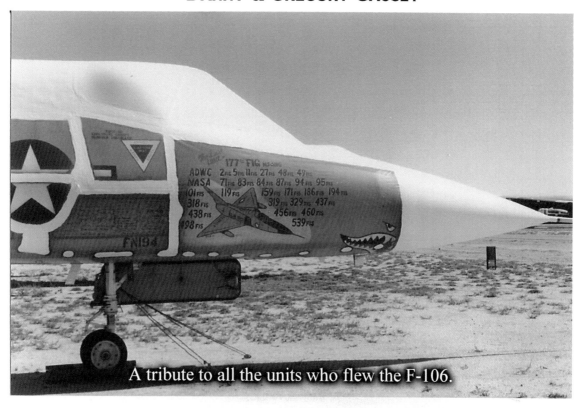

A tribute to all the units who flew the F-106.

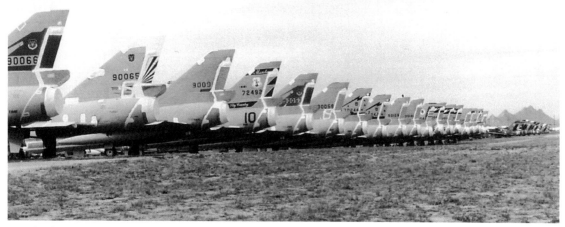

F-106s await their turn to be converted into unmanned drones for live missile firings. These were designated as QF-106s. Three were dropped into the Gulf of Mexico to be used as artificial reefs.

C-130 Hercules

"Memphis Belle" makes another appearance, this time on a Lockheed C-130 Hercules. More than 2,000 C-130s have been built and the aircraft serves in a variety of versions (more than 40), in service with more than 50 nations. It's been used as a cargo transport, gunship, firefighter, medical evacuation, search and rescue and combat control. With the flight of the first prototype in 1954, it can boast of the longest continuous production run of any military aircraft. **C-130A 57-0463**

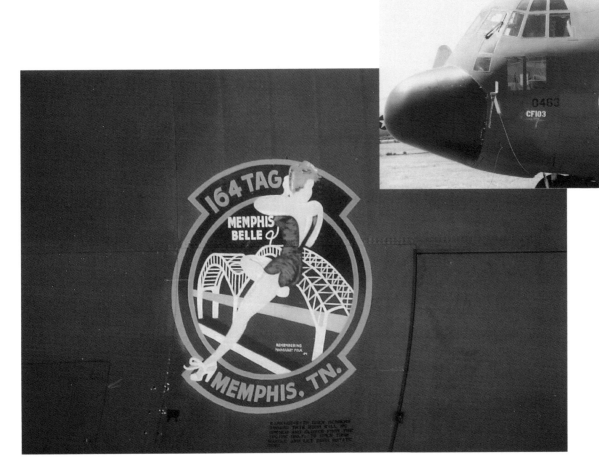

OV-1 Mohawk

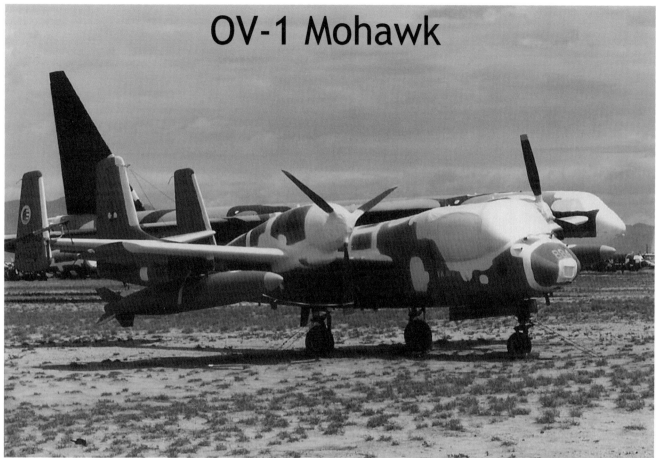

The Grumman OV-1 Mohawk aircraft first flew in 1959 and served as an active reconnaissance platform until removed from duty in 1996. It was operated by the U.S. Army and served in such diverse locations as:Vietnam, Europe, Korea, Central and South America, Alaska, and Desert Storm. Grumman originally estimated the Mohawk to have a twenty-year service life, but they soldiered in, in many variants, for thirty-seven years. The primary models built over the aircraft's lifetime included: OV-1A visual and photographic recon), OV-1B (included a side-looking radar (SLAR) pod), OV-1C (added infrared capability), and the OV-1D with the SLAR pod and larger wings. Other electronic warfare versions were built and the aircraft was also outfitted for combat, to all reports acquitting itself well in Vietnam. There is even an unconfirmed report of a Mohawk downing a Mig. There were issues between the Air Force and Army about the Army flying fixed wing combat missions and the Mohwak was eventually withdrawn from its active combat role. As an instructor for the U.S. Army at Ft. Huachuca, Arizona, our father taught the OV-1 photographic and sensor systems; and enjoyed those times he was able to get back in the cockpit to fly and photograph the great Southwest.

F-16 Falcon

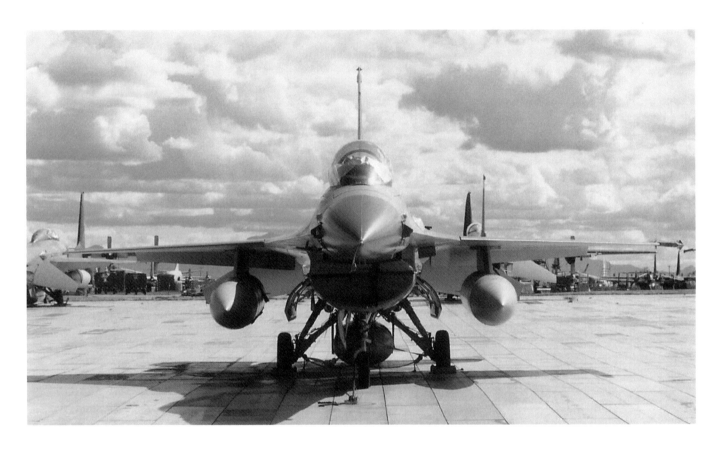

It's inevitable that all U.S. Military aircraft will eventually find their way to AMARC, spending the last of their lives parked on the hard desert landscape. Even the venerable F-16 Fighting Falcon is an AMARC resident. As the U.S. Military continues to draw down, such 'recent' first-line fighters such as the F-16, F-15 and F-14 are waiting in storage at AMARC. Will their stay be temporary; will they fly out again?

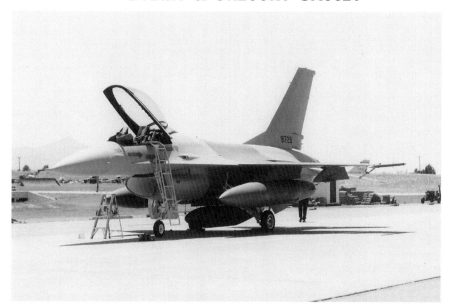

The F-16 is the largest Western fighter program with over 4,000 produced since production started in 1976. Although AMARC stores many F-16s, the model is expected to remain in service until 2025. During Operation Desert Storm F-16s flew over 13,000 sorties, performing more combat missions than any other coalition aircraft. The Falcon was designed to be a cost-effective and multi-purpose aircraft incorporating advanced avionics. It was the first fly-by-wire combat aircraft. Many air arms throughout the world fly the F-16, among them (but not all inclusive) are: Belgium, Greece, Denmark, Israel, Norway, Portugal, Thailand, Turkey and many others.

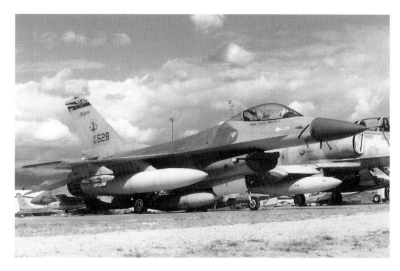

A-7 Corsair II

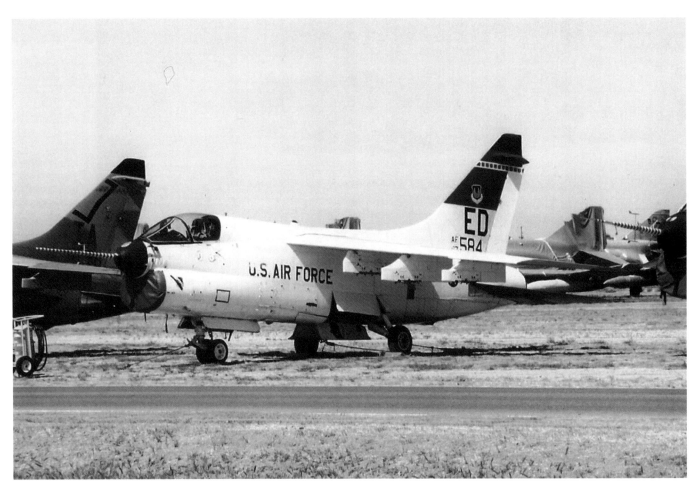

The Ling-Temco Vought A-7 Corsair II was another Navy design that was also later adopted for use by the U.S. Air Force. A-7s were used extensively in Vietnam. The example above is an Air Force version and is painted as an Air Force test and research aircraft. The ones on the next page represent a Navy test version and the other, oddly enough, bears U.S. Army markings. The folding wings are a heritage of its birth as a carrier aircraft and are utilized in storage at AMARC as a space-saving measure.

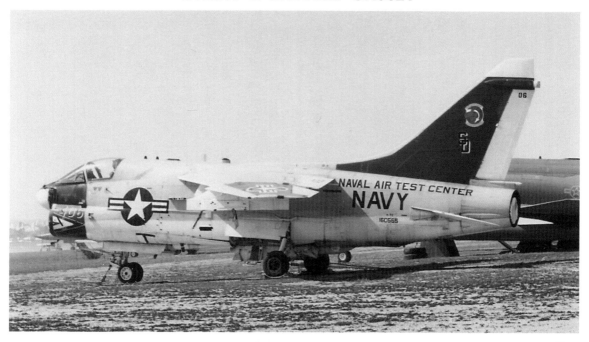

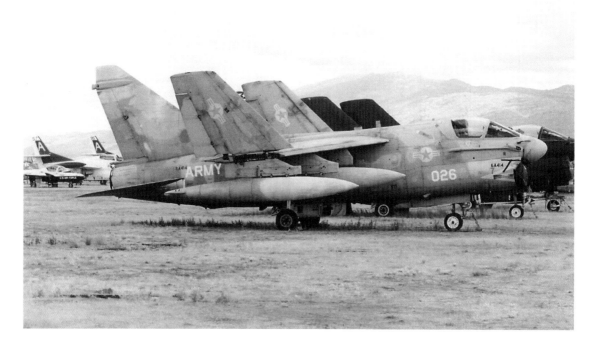

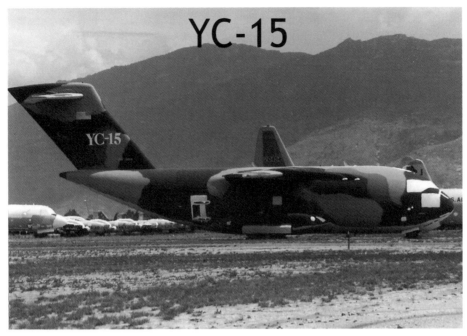

The McDonnell Douglas YC-15 was a prototype as the Air Force's next generation of medium, short take-off and landing (STOL) tactical transports. The YC-15 later saw life as the McDonnell Douglas C-17 Globemaster III, the Air Force's newest tactical airlift aircraft. True to its "Regeneration" capability, after several years in storage, AMARC returned the YC-15 to flying status where it was used to evaluate new transport technology.

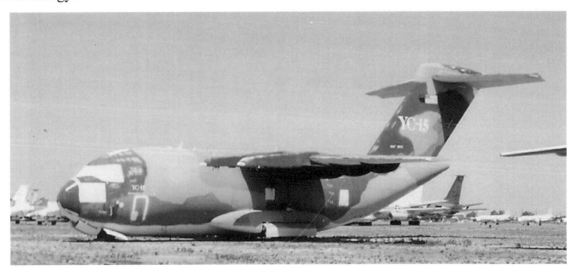

YC-14

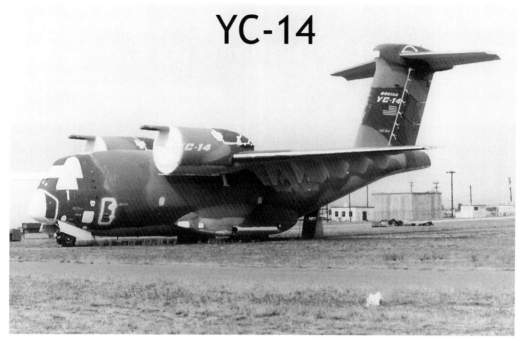

The Boeing YC-14 competed as a potential prototype for the Air Force's next generation of medium, short take-off and landing (STOL) tactical transport.

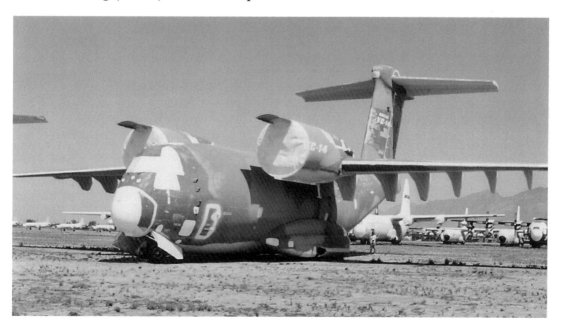

Boeing 307 Stratoliner

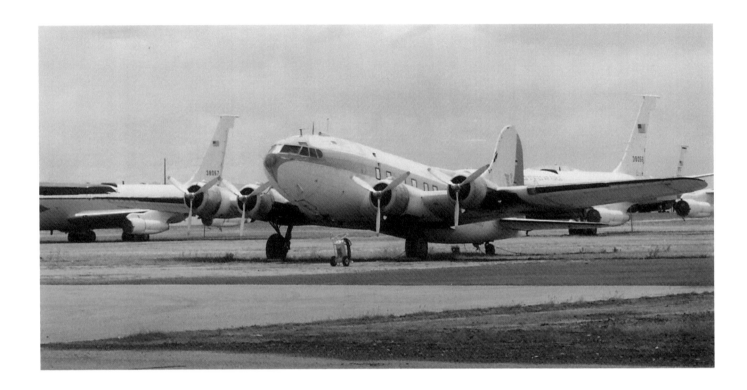

The Boeing 307 Stratoliner was a trailblazing commercial airliner, with its pressurized cabin and ability to carry thirty three passengers. This particular aircraft was built in 1939. Only ten were ever built, and five were designated as C-75s and used as transports in WWII.

In 1994 a team of maintenance personnel from Boeing traveled to AMARC to prepare the aircraft for a return to the Boeing factory in Seattle. Back at the factory the aircraft was restored to its original configuration and later displayed at the Steven F. Udvar-Hazy Center near the Washington, D.C. Dulles airport.

Howard Hughes purchased a Stratoliner and had it outfitted as a personal "flying penthouse" complete with: master bedroom, two bathrooms, galley, bar and a living room.

Boeing 707

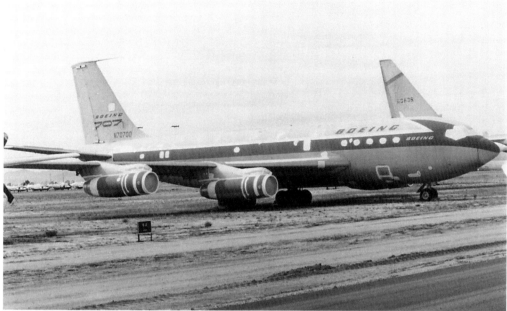

The Boeing 707 (above) was the first successful commercial passenger jet and the progenitor to the famed series of '7X7' aircraft. More than 1,000 were built and it set the standard for commercial jets for many years. The four J-57 engines used to power the aircraft were also used on early 'Century' fighters and the B-52. Boeing produced the 707 until 1978. The KC-135 and all the other 135 variants were based on this classic airframe. The aircraft pictured here is the original prototype.

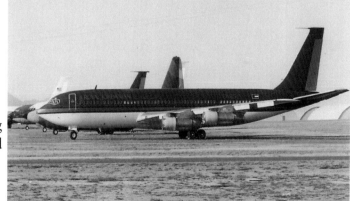

A Royal Jordanian Boeing 707 (right) rests on the hard desert at AMARC.

F-15 Eagle

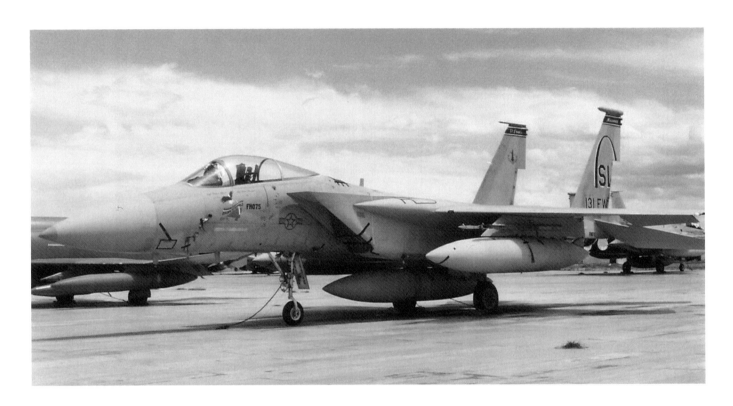

 The McDonnel Douglas F-15 Eagle was designed and built to be, at the time, the dominant all-weather air superiority fighter. It was the first such aircraft to be procured since the F-86 Sabre of Korean War fame, and as an 'air superiority fighter' it's racked up an impressive 104 to 0 kill ratio among the many air arms that fly the Eagle. The first prototype flew in 1972 and later versions (F-15E) of the aircraft may be expected to be flying to 2025. The F-15E 'Strike Eagle' is a long-range attack aircraft. Israel, Japan and Saudi Arabia also fly the F-15.

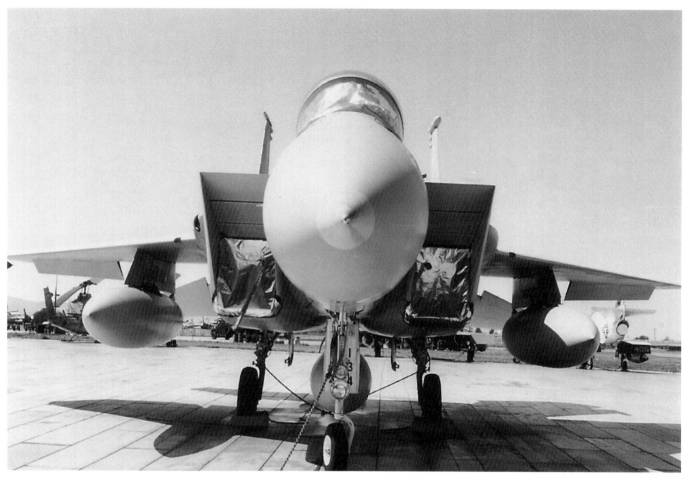

Even with the F-15s air superiority role due to be replaced by the F-22 and its attack role by the F-35 Joint Strike Fighter, the Air Force is taking efforts to maintain the F-15 as a dangerous adversary. Potential upgrades include new radars and the Joint Helmet Mounted Cueing System.

CH-54

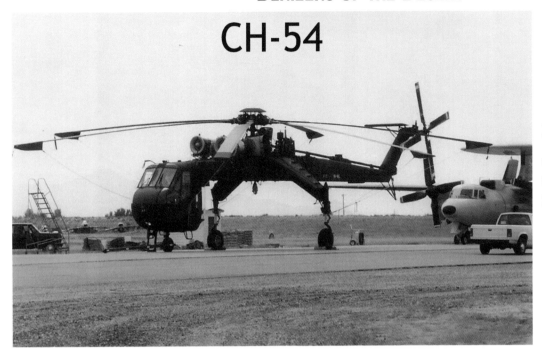

The CH-54 *Tarhe* is named for a Wyandot Indian Chief called *The Crane* (*Tarhe*). It can carry a 20,000 lb. Payload.

Titan II

The Titan II was developed as a weapon, an Intercontinental Ballistic Missile (ICBM) and later used as a space launch vehicle for the Air Force, National Aeronautics and Space Administration (NASA) and the National Oceanic and Atmospheric Administration (NOAA). It first flew in 1961, was combat-ready in 1963, and the last ICBM was deactivated in 1987.

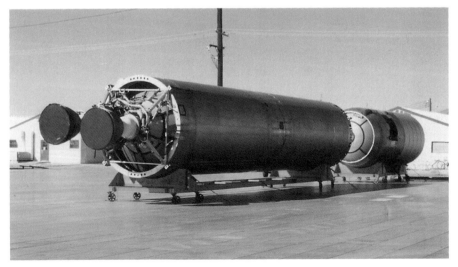

C-97 Guppy

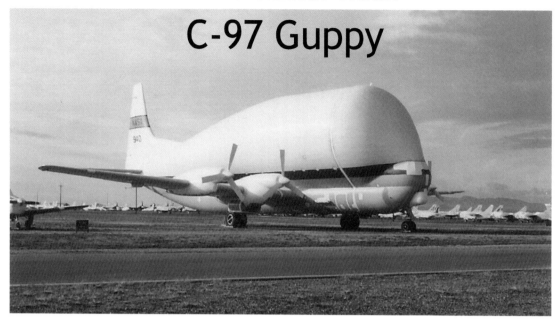

AMARC gave up a KC-97J in 1965 and it eventually became a "*Super Guppy*." Parts from five KC-97s were required to create this flying behemoth with the ability to carry a 41,000 pound payload. It was designed specifically for transporting parts for NASA's Saturn IV and V booster rockets and from the Lunar Module.

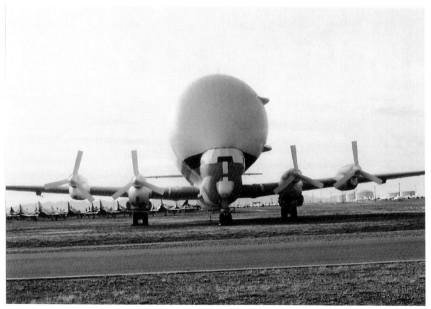

F-100 Super Sabre

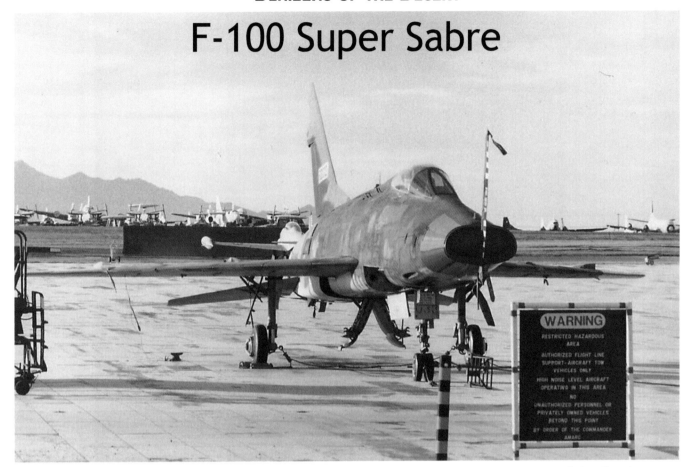

The North American F-100 Super Sabre was the first of the 'century' fighters and the first in many other areas as well: first capable of supersonic speed in level flight and one of the first to extensively use titanium in its construction. It served with active Air Force units from 1954 to 1971 and served on with Air National Guard units until 1979. The "Hun" (short for 'Hundred') served as a fighter-bomber flying combat missions in Vietnam.

The USAF Thunderbird aerial demonstration team flew the F-100 from 1956 to 1968 (except for a brief time in 1964 when they flew the F-105 Thunderchief).

The Super Sabre was a successful export aircraft with France, Denmark, Turkey and Taiwan all flying variants of the F-100.

Over three hundred F-100s were converted to QF-100s, remote controlled drones, used for live missile firings by Air Force aircraft. The photos on these pages show AMARC F-100s undergoing this drone conversion process.

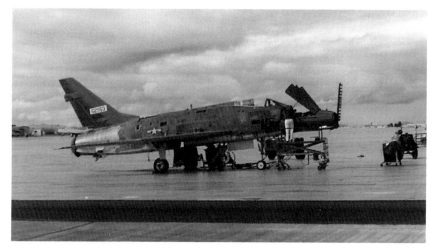

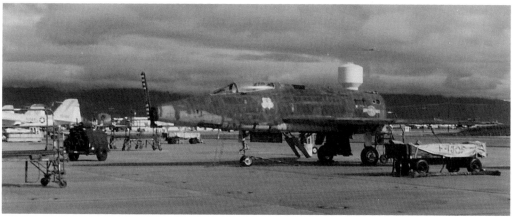

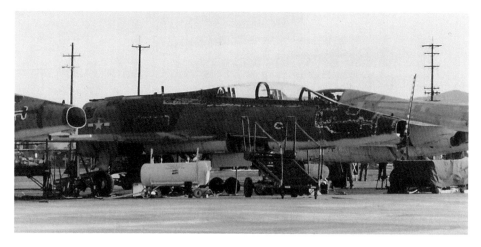

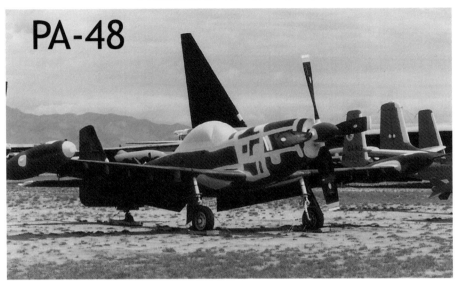

A derivative of the famed P-51 Mustang, the Piper PA-48 Enforcer was intended to be a turboprop powered close air support aircraft. Not surprisingly, given its design heritage and new power plant, the prototype supposedly flew well, but failed to secure a production contract with the U.S. Air Force.

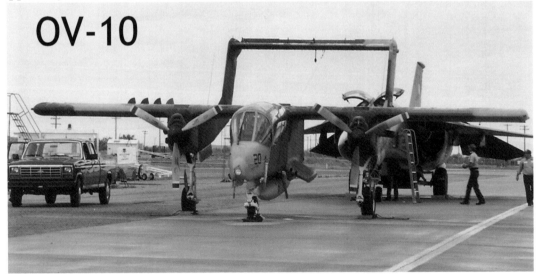

A more successful close air support and observation aircraft was the North American Rockwell OV-10 Bronco. It was developed for Counter Insurgency (COIN) and Forward Air Control (FAC) duties. It was used by the Marines, Air Force and Navy. The OV-10 had short take off and landing capability and carried a wide array of munitions. It also found use with foreign governments and various U.S. Civil agencies.

F-101 Voodoo

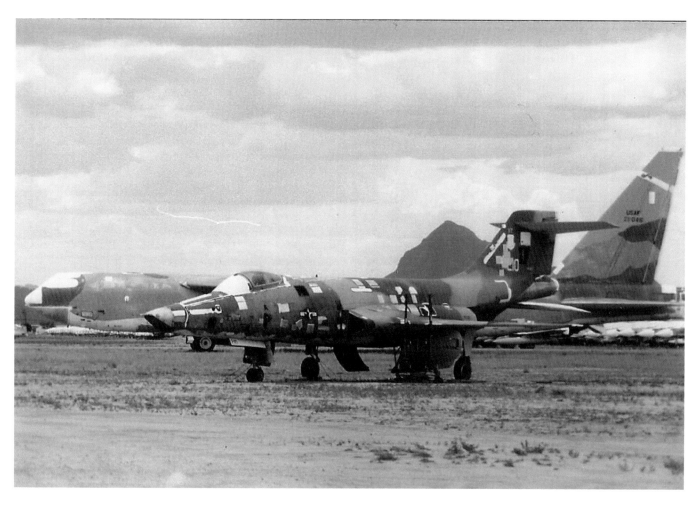

The McDonnel F-101 Voodoo was designed as a long-range bomber escort for the Strategic Air Command (SAC), yet ended up serving in a number of other roles. It saw duty as an all-weather interceptor (F-101B) for the Air Defense Command (ADC), as a nuclear-capable fighter-bomber (F-101A/F-101C) and a reconnaissance aircraft (RF-101, which saw duty during the Cuban Missile Crisis and Vietnam) for the Tactical Air Command (TAC). The aircraft pictured here is an RF-101.

MiG15 and 17

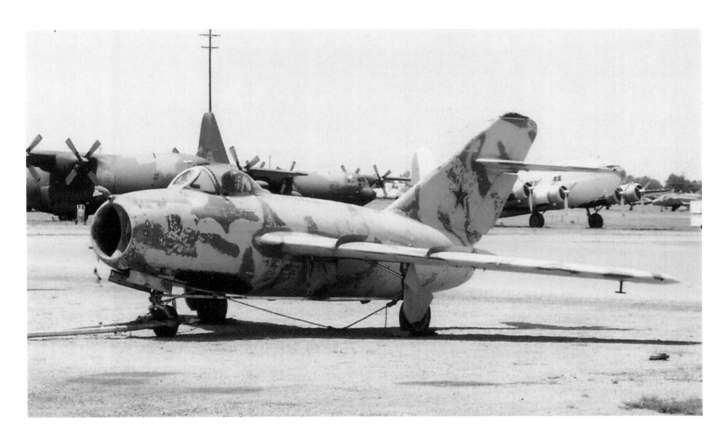

AMARC offers a wealth of experiences for an aircraft enthusiast. Pictured above (with the classic Boeing 307 Stratoliner and ubiquitous C-130 Hercules in the background) is a <u>Mikoyan-Gurevich</u> MiG-15. The MiG-15 was the first successful swept-wing jet fighters, and it quickly took control of the skies over Korea until the Air Force fielded the F-86 Sabre. The MiG-15 was the progenitor of a series of Soviet-inspired fighters that challenged American air superiority for decades. The USSR, and its Warsaw Pact built around 12,000 MiG-15s in several variants.

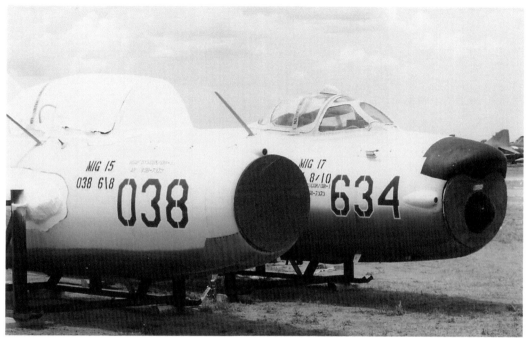

The MiG-17 (# 634, above, on the right) was the primary combat aircraft for the Vietnamese People's Air Force. Along with newer MiG-19s and 21s, the MiG-17 saw considerable combat with American aircraft during the 60s and 70s.

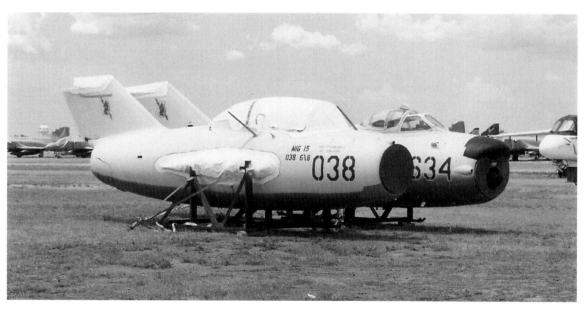

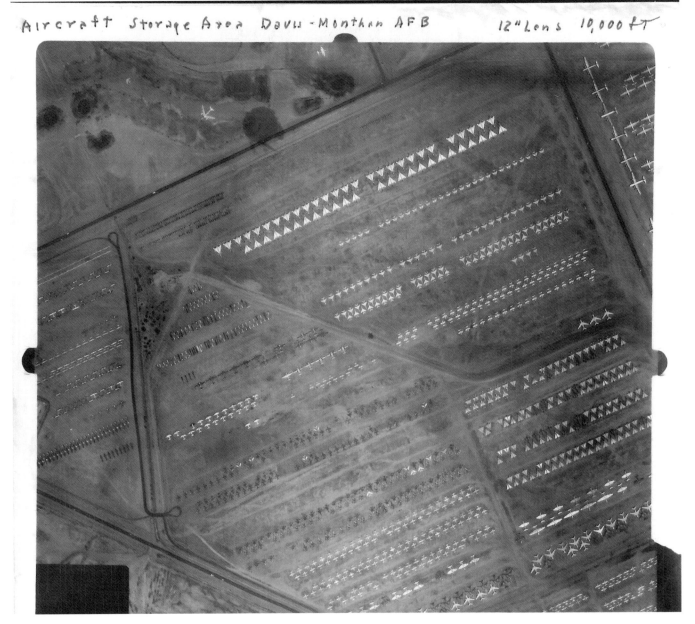

Aircraft Storage Area Davis-Monthan AFB 12"Lens 10,000 FT

Aerial photograph of the AMARC facility, date unknown. Provided by Dale Causey, who donated his aviation photographs to the National Museum of the United States Air Force.

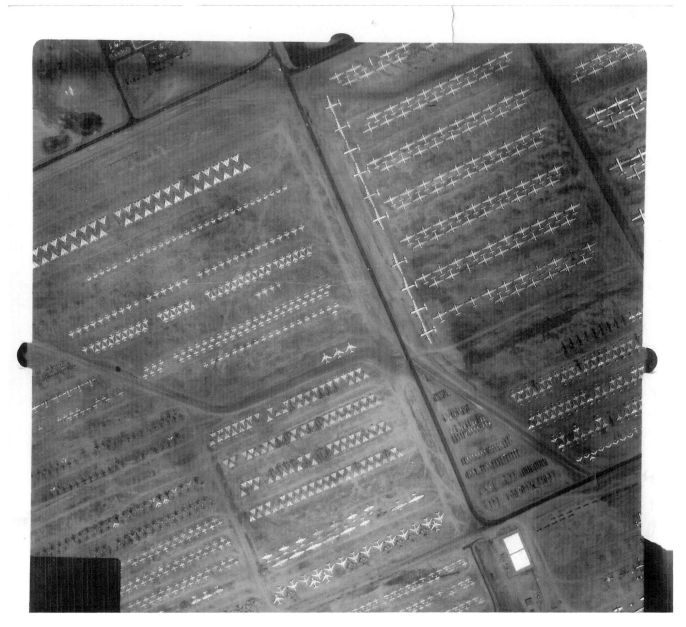

Aerial photograph of the AMARC facility, date unknown. Provided by Dale Causey, who donated his aviation photographs to the National Museum of the United States Air Force.

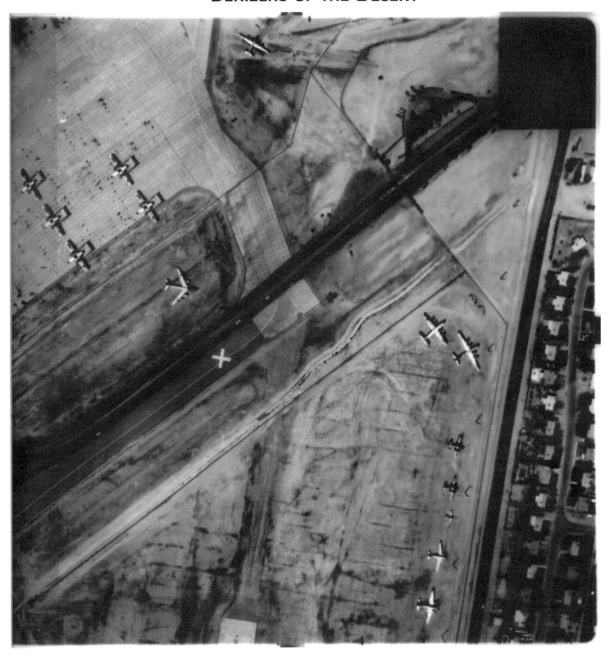

Aerial photograph of the AMARC facility, date unknown. Provided by Dale Causey, who donated his aviation photographs to the National Museum of the United States Air Force.

AMARC's Navy Aircraft

Danny was a Navy veteran who served his time aboard the aircraft carrier U.S.S. Midway. No doubt the sight of Navy aircraft at AMARC brought back memories of the carefully choreographed dance of the flight deck, the scream of jets, the roar of turboprops, the dramatic sounds of aircraft catching the hook and the whoosh of the catapult.

As the following pictures indicate, AMARC is the final home for all kinds of aircraft. It may be a bit ironic that after decades of landing on the short, pitching deck of a ship, many of these stalwart warriors of the air land on a long runway and are pulled to their final resting place on the hard desert soil.

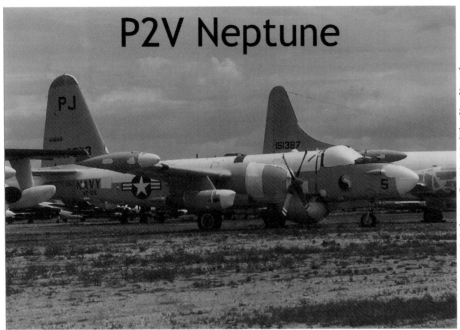

P2V Neptune

The Lockheed P2V Neptune was the Navy's main patrol bomber and anti-submarine warfare (ASW) aircraft between 1947 and 1978. As proof of the aircraft's patrol range, in 1946 a Neptune flew non-stop from Perth, Australia to Columbus, Ohio, a distance of over 11,00 miles, in two and a half days. Today, the Neptune flies on as an aerial fire bomber.

The Grumman S-2 Tracker was an Anti-Submarine Warfare (ASW) aircraft for the U.S. Navy. It entered service with the Navy in 1954. The Tracker flew in its ASW role until 1976, when it was replaced by the S-3 Viking. Grumman produced over 1,000 Trackers. Like the P2 Neptune, several Trackers have found careers as fire bombers, fighting forest fires.

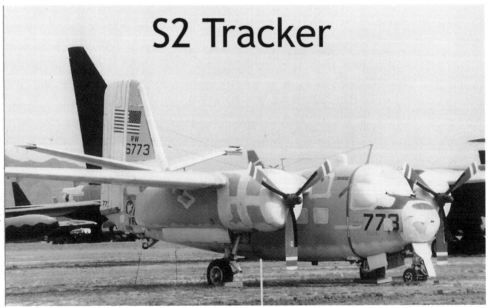

S2 Tracker

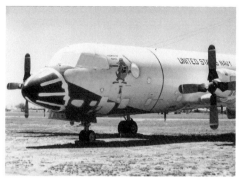

P-3 Orion

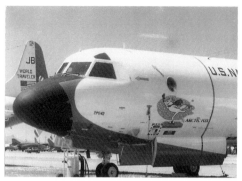

Based on the Lockheed L-188 Electra, the P-3 Orion served as a replacement for the P-2 Neptune. Its original cold war mission was to find and attack enemy ballistic and fast attack submarines. It carried a wide array of sensors and weapons for this task. The Orion was able to shut down some of its engines and achieve high loiter times on its patrol duties. It saw duty during the Cuban Missile Crisis, Vietnam and conflicts with Iraq. As with its Lockheed stable mate, the C-130 Hercules, the P-3 has found users throughout the world: Argentina, Australia, Brazil, Chile, Germany, Greece, Iran, Japan, New Zealand, Norway, Pakistan, Portugal, Republic of China (Taiwan), South Korea, Spain, and Thailand.

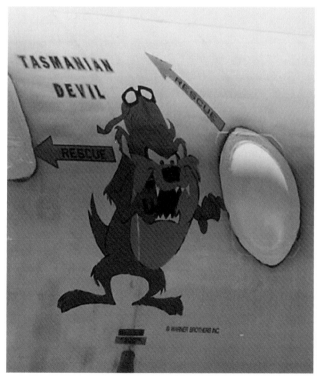

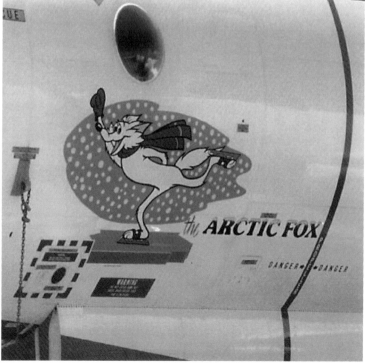

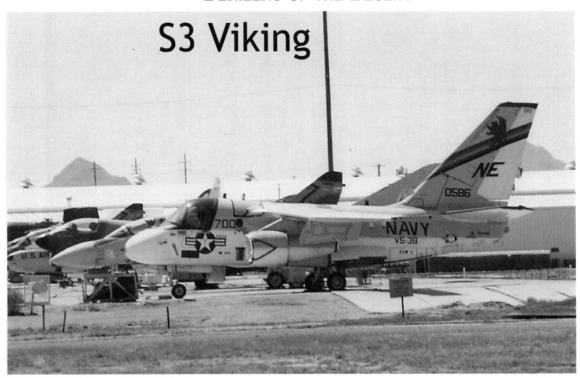

S3 Viking

The Lockheed S-3 Viking is the latest in a long line (PV-1 Ventura, PV-2 Neptune, S-2 Tracker, P-3 Orion) of Anti-Submarine Warfare (ASW) aircraft, whose job was to find, track and destroy enemy submarines. With the retirement of the Navy A-6, the Viking was also the primary aerial refueling platform. The S-3 entered active service in 1974, and a total of 186 S-3As were built. S-3s saw duty in the Gulf War performing tanker, attack and Electronic Intelligence (ELINT) missions.

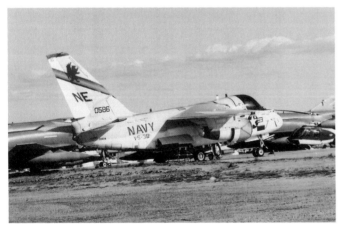

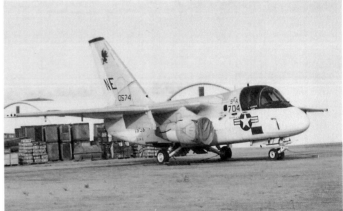

F-14 Tomcat

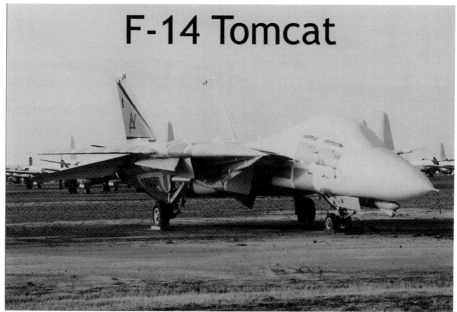

The Grumman F-14 Tomcat is the latest in a long line of Grumman Navy fighter 'cats': F4F Wildcat, F6F Hellcat, F7F Tigercat, and F8F Bearcat (there were also Panthers and Cougars). The F-14 was the greatest prowler of them all: a supersonic, swing-wing, twin-engine, two-seat, air superiority fighter, fleet defense interceptor and reconnaissance platform. It replaced the F-4 Phantom II and from 1974 to 2006 it reigned supreme in the air over the world's oceans. During Operation Desert Storm F-14s flew Combat Air Patrol (CAP) missions, escorted strike fighters and flew recon missions.

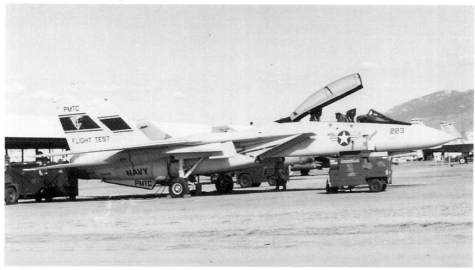

A-4 Skyhawk

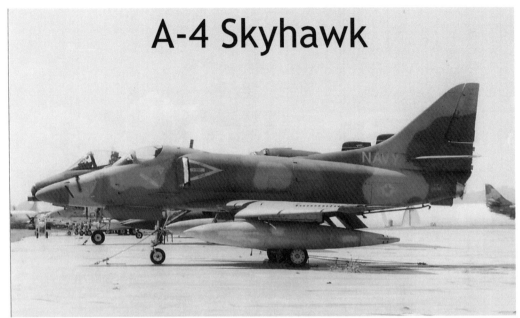

The Douglas A-4 Skyhawk may often be overlooked in the annals of great aircraft. Yet it has proven to be a nimble and adaptable aircraft, one of the finest examples of that delicate balance of performance, size, weight and complexity. It first flew in 1954 and remained in active U.S. Service until 1975. A total of 2,960 Skyhawks were built, including 555 two-seat trainers. Skyhawks served in the air arms of many other nations and were used to great success as aggressor aircraft in teaching air combat tactics to U.S. airmen.

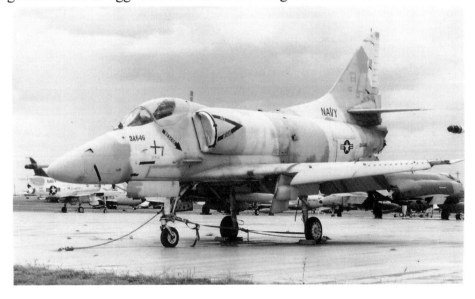

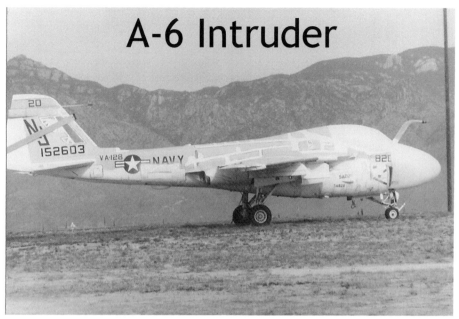

A-6 Intruder

The Grumman A-6 Intruder was a twin-engine, all-weather medium attack aircraft. Variants of the A-6 also served as tankers and electronic warfare versions. The Intruder entered active service in 1963 and was retired in 1997. During its combat life, the Intruder saw duty in Vietnam, Lebanon, Libya, Operation Desert Storm (1991) and Bosnia (1994).

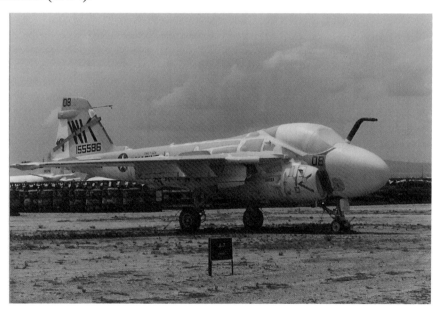

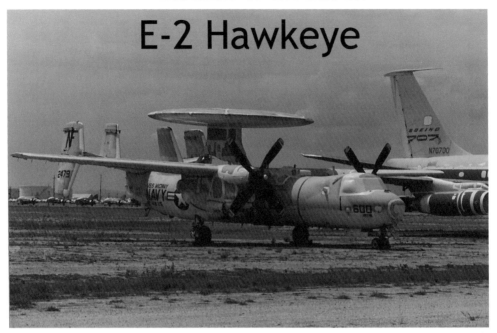

E-2 Hawkeye

The Grumman E-2 Hawkeye is a carrier-based Airborne Early Warning (AEW) aircraft. It's the eyes (via the large radome on the top) for the carrier battle group, providing critical early warning, command and control, surface surveillance, strike and interceptor control and coordinating search and rescue functions.

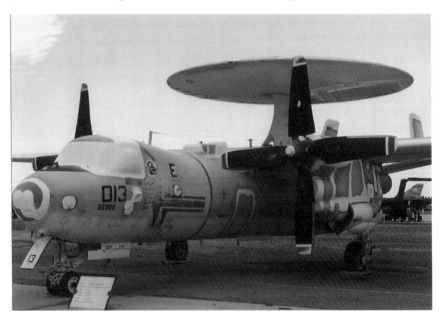

The C-2 Grey-hound is a Carrier On-board Delivery (COD) transport based off the Grumman E-2 airframe. It uses the same wings and engines, with a larger fuselage and a rear load-ing ramp. The first proto-type flew in 1964 and the aircraft were overhauled in the 1973 to extend their service life. In the background can be seen the distinctive black tail of a B-52D and radome of an EC-121.

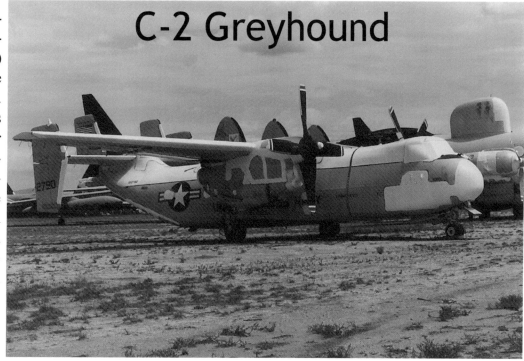

C-2 Greyhound

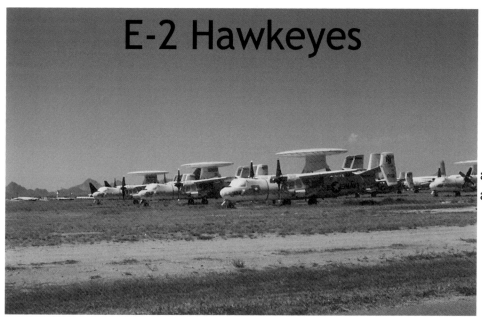

E-2 Hawkeyes

More E-2 Hawkeyes, a long way from the ocean, await their fate.

R5D Skymaster

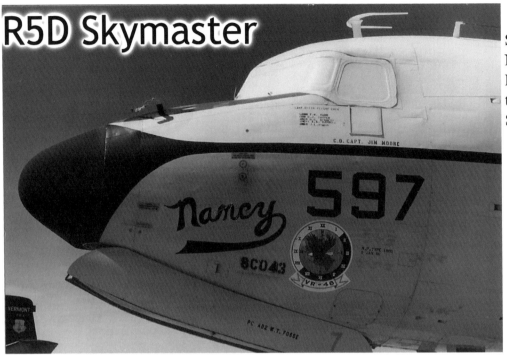

The Douglas R5D Skymaster *Nancy,* was the Navy version of the C-54. Most R5Ds were used by the Naval Air Transport Service (NATS).

T-2C Buckeye

The U.S. Navy T-2C Buckeye was used to train Navy and Marine Corps pilots and Naval Flight Officers. The T-2 "Buckeyes" were built by North American in Columbus, Ohio. A total of 273 were built.

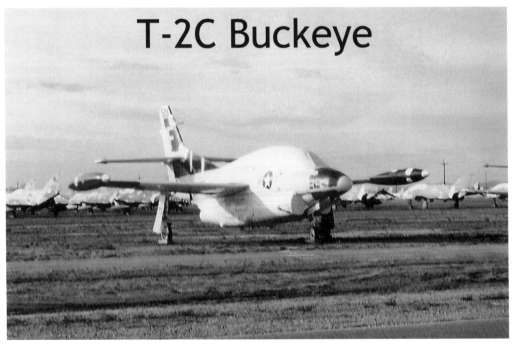

A-3 Skywarrior

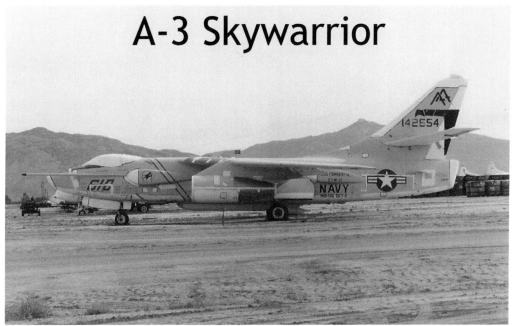

The A-3 Skywarrior, built by Douglas, was used in a variety of roles: strategic bomber, tanker and electronic intelligence. It had a long life in Navy service, from 1956 to 1991. The Air Force flew their own version, the B-66 Destroyer.

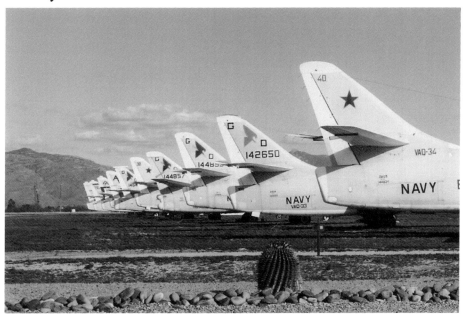

F-8 Crusader

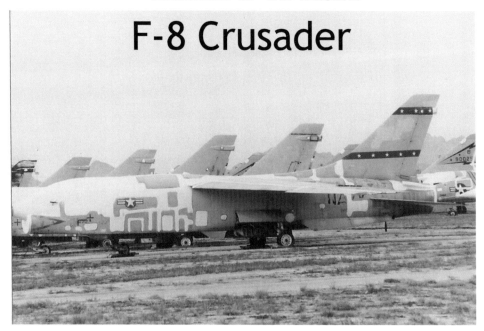

The first F-8 Crusader flew in 1955 and it served as the premier Navy fighter until retirement in 1976. Built by Chance-Vought, it was the last American fighter aircraft with guns as the primary offensive weapon; many referring to it as "The Last Gunfighter." In fact, it would be credited with the best kill ratio, 19:3, during the Vietnam conflict. Its kills included 16 MiG-17s and 3 MiG-21s.

SH-2 Seasprite

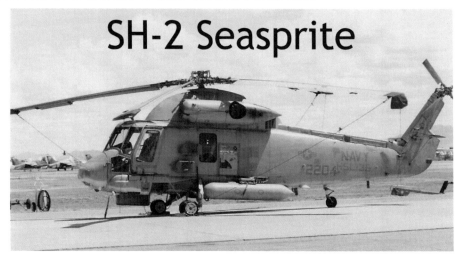

The Kaman SH-2 Seasprite was a ship-based, anti-submarine helicopter that also included anti-surface threat capability, by way of its over-the-horizon targeting abilities. It was retired in 1993.

Danny Causey also liked to photograph lightning in Tuscon, Arizona.

Dale Causey, ever the aviation photographer, took this picture of a Martin B-10 (left) at Chanute Field, Illinois when he was around 12 years old. Later, to his delight, he found himself flying as a crewman in B-10's at Nellis Army Air Field in World War II.

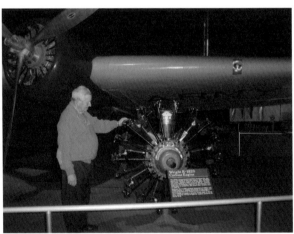

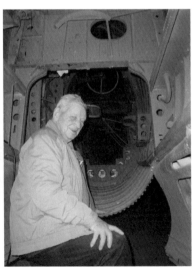

In 2006, Dale was a special guest at the National Museum of the United States Air Force. He donated his photographs and papers to the museum archives and was allowed special access to the only surviving Martin B-10. The photo, above right, shows him back in the bomb bay, decades after his first-ever view of Hoover Dam through the bomb bay of an airborne B-10.

Photos of Dale Causey by Greg Causey

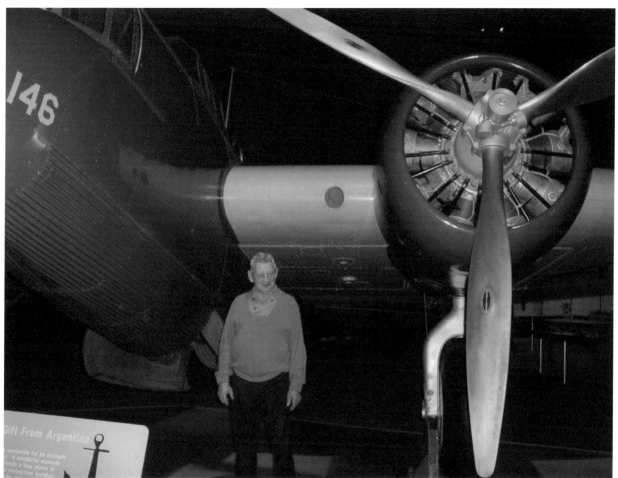

Note the "Argentina" on the aircraft placard. When I and my brother were kids my Dad took the family to the Air Force Museum, long before it was in its present facility. I remember my father asking a docent "Where's the B-10?" Dad was told there were no more B-10s. That's when my father told the museum person that he'd had an Argentine Air Force officer, Major Rafael Volz, in one of his classes (my father was then an Instructor at Chanute AFB) and that Major Volz had told my father that they had an old B-10 in one of their hangers. I have no way of knowing if this was the progenitor of the museum obtaining the aircraft, but I distinctly remember the incident. I also remember getting a copy of Quentin Reynolds *They Fought for the Skies* and a Fokker DR-I model kit from the museum gift shop (editor).

Photos of Dale Causey by Greg Causey

DALE K. CAUSEY

Our father finished his career in the 60s and 70s following two of his loves, aviation and photography, by teaching aerial reconnaissance photography and sensor operation, and getting flight time in Grumman OV-1 Mohawks (below and right) at Fort Huachuca, Arizona.

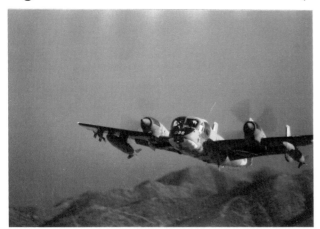
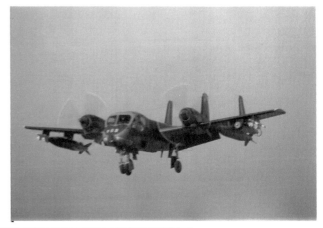

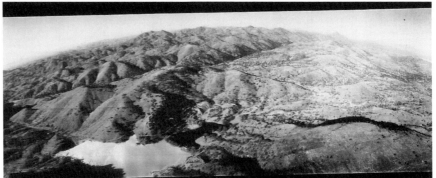

OV-1 Mohawk panoramic nose camera recon photo.

Photographs courtesy of Dale Causey

Photos by
Dale K. Causey

Flight plan

Roell is briefed on a mission flight plan by OV-1 Mohawk pilot Warrrant Officer 2 Larry G. Wilkinson.

SCOUT Section B

Page 1
Thursday
September 7, 1972

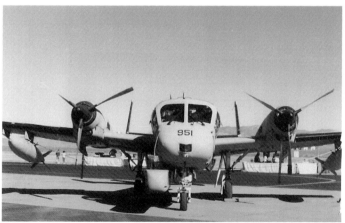

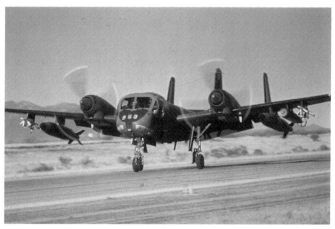

Photographs courtesy of Dale Causey

Following his retirement from working for the U.S. Army, Dale became a staple on the southwest air show and fly-in circuit. He attended many shows, photographing events for publications and free-lance work, and meeting many aviation notables.

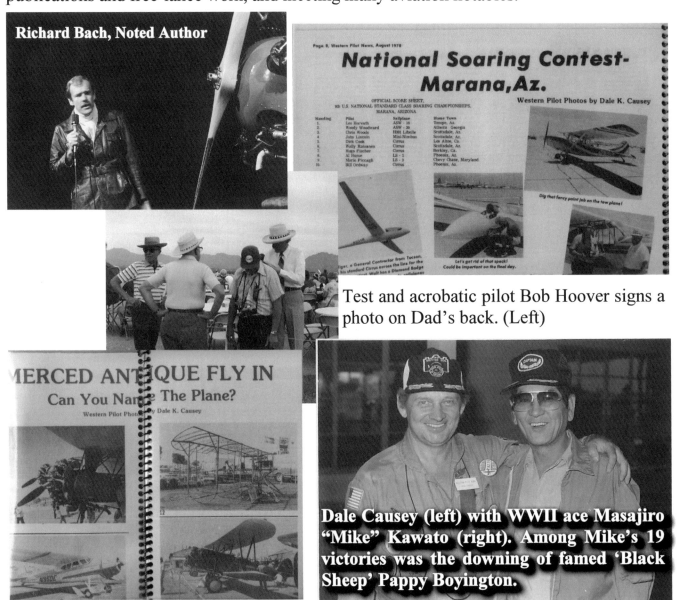

Richard Bach, Noted Author

Test and acrobatic pilot Bob Hoover signs a photo on Dad's back. (Left)

Dale Causey (left) with WWII ace Masajiro "Mike" Kawato (right). Among Mike's 19 victories was the downing of famed 'Black Sheep' Pappy Boyington.

Photographs courtesy of Dale Causey

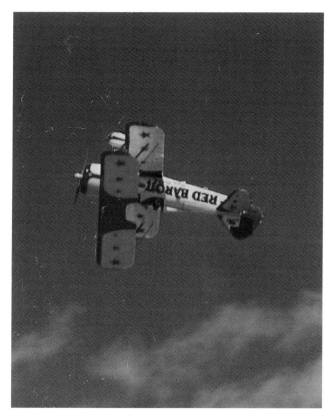

One of the high points of Dad's time on the air show circuit was the chance to get back into the cockpit of a Red Baron Stearman, and do a formation loop (above left). He flew with the late Red Baron pilot Sonny Lovelace. Dad and Sonny are pictured below.

WESTERN PILOT NEWS

Don Ferguson
Editor-Publisher

Reid Saindon
Contributing Editor

Raymond Daniels
Business Manager

Dale K. Causey
Photography

Gayle Clapp
Art Director

ADVERTISING RATE CARD AVAILABLE ON REQUEST.
Single Issue $1.00 • Subscription Rate $6.00/Year

Western Pilot News welcomes unsolicited manuscripts and photographs, but will not be responsible for handling or return. Material should be accompanied by return addressed, stamped envelope.

No part of Western Pilot News shall be reproduced without written permission.

Address change: Send old mailing label with new address to our office.

WESTERN PILOT NEWS CO.
P.O. Box D / Chandler, AZ 85224 / Phone (602) 963-4710

Photographs courtesy of Dale Causey

ACKNOWLEDGEMENTS

Many thanks to my wife, Joan, who showed extreme patience, and provided much needed encouragement and advice throughout the many months of putting this work together.

Thanks to the following individuals who provided research help with the following aircraft::

Joseph Hodges, The Warthog Pen Webmaster, for his assistance with the A-10 chapter.
www.warthogpen.com

David de Botton, for his help with the F-111 chapter.
www.F-111.net

REFERENCES

The following sources and reference material contributed to this book.

The History of Aircraft Nose Art: WWI to Today, Jeffrey L. Ethell and Clarence Simonsen, © 1991, Motorbooks International Publishers and Wholesalers, Osceola, WI

Weapons of the Eighth Air Force, Frederick A. Johnson, © 2003, MBI Publishing Company, St. Paul, MN

Aircraft Nose Art: 80 Years of Aviation Artwork, J.P. Wood, © 1996, Salamander Books Ltd., New York, NY

Inside AMARC: The Aerospace Maintenance And Regeneration Center Tucson, Arizona, Jerry Fugere and Bob Shane, © 2001, MBI Publishing Company, Osceola, WI

Boeing B-52 Stratofortress 2nd Edition, William Holder and Robert Woodside, © 1988, TAB Books, Blue Ridge Summit, PA

F-111 in Action, Lou Drendel, © 1978, Squadron/Signal Publications, Inc., Carrollton, TX

KC-135 Stratotanker in Action, C.M. Reed, © 1991, Squadron/Signal Publications, Inc., Carrollton, TX

A-10 Warthog in Action, Lou Drendel, © 1981, Squadron/Signal Publications, Inc., Carrollton, TX

B-52 Stratofortress in Action, Lou Drendel, © 1975, Squadron/Signal Publications, Inc., Carrollton, TX

F-106 Delta Dart in Action, Captain Don Carson and Lou Drendel, © 1974, Squadron/Signal Publications, Inc., Carrollton, TX

OV-1 Mohawk in Action, Terry Love, © 1989, Squadron/Signal Publications, Inc., Carrollton, TX

FB-111A.net www.fb-111a.net

Pat's World of the F-106 Delta Dart www.f-106deltadart.com

Airlift Tanker Association www.atalink.org

Warthog Territory www.a-10.org

National Museum of the USAF www.nationalmuseum.af.mil

Dancing With Natasha (ISBN 978-1-934446-00-3) takes the reader from "I Can't Dance," to "I'm A Dancing Machine," detailing the rewarding endeavor of learning Ballroom Dance. In this engaging, witty and poignant memoir, Greg and his wife Joan make the trek to the Arthur Murray Dance Studio in Dayton, Ohio, to learn to dance. What they find is nothing short of miraculous. Foreword written by Barbara Haller, four-time United States Professional Theatrical Arts Dance Champion.

Quality Sex: The Sensuous Side of Process Improvement (ISBN 1-4137-6745-1). What would happen if you combined Joseph Juran, Hugh Hefner, W. Edwards Deming and Monty Python? It would probably be something like *Quality Sex*, an off-the-wall look at Quality and Process Improvement techniques.

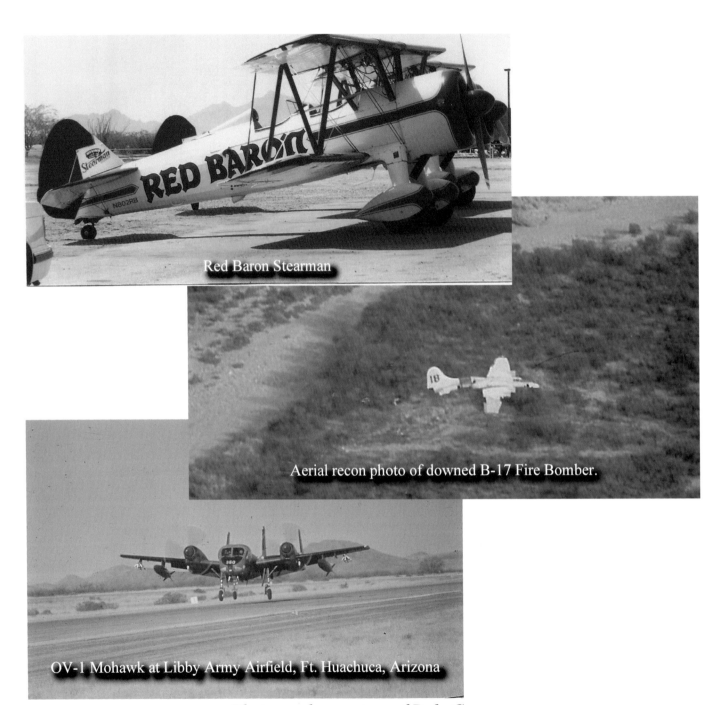

Red Baron Stearman

Aerial recon photo of downed B-17 Fire Bomber.

OV-1 Mohawk at Libby Army Airfield, Ft. Huachuca, Arizona

Photographs courtesy of Dale Causey

LaVergne, TN USA
27 March 2010
177290LV00002B

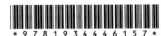